THE FLOATING BRUSH

Learning Shodo from a
Kendo Master

by

Dan Popp

Harrisburg, Pennsylvania
www.seizanshodo.com

Cover art:
Yume (dream) / 2-tone ink on rice paper
Brushed February 2013 by the author

Printed in the United States of America

PHOTO CREDITS
All photographs in this publication were taken by the author, Elissa Gioffre, and Jerry Robinette and are from the private collection of the author.

Library of Congress Control Number: 2014944773

ISBN-13:
978-1-62487-029-3 - paperback
978-1-62487-030-9 - ebook

DEDICATION

To all my martial arts instructors - past, present, and future.

To Kim Sensei – for your teachings and inspiration.

So long as we do not go beyond mere talking,
we are not true knowers.

—Takuan Soho (1573 – 1645)
Zen priest
Author / The Unfettered Mind

Pursue your study to the end, awaken your irresistible force,
practice ceaselessly until your heart is immovable,
and then you will understand.

—Yamaoka Tesshu (1836 – 1888)
Founder / Muto Ryu school of swordsmanship

Acknowledgments

First, I cannot express how grateful I am to Kamel Press. Kermit, Deanie and rest of the team there have been very supportive of this effort to put the little-known art of Japanese Shodo into the public eye. Thank you!

To my parents, Frank and Carol… I wouldn't be who I am today without your ongoing support.

To my daughters, Britteni and Kayla… thanks for the encouragement and enthusiasm you show every day.

To Elissa Gioffre… I'm grateful, first and foremost, for your love. Thanks for the excellent job designing the book cover!

I must recognize and pay respect to each of my martial arts instructors: Toby Cooling (Order of Isshin Ryu), Rick Manglinong (Kombatan, Modern Arnis), Isham Latimer (Chi Ryu Jujitsu), and Dave Joyner (Kendo).

A special thank you to Master Bud Ewing, 9th dan Order of Isshin Ryu karate. I cannot begin to repay you for the time, effort, and patience in working with me over the years.

My New York Order of Isshin Ryu brothers: Isham Latimer, John Costanzo, and John McDonald. I hope our research into martial arts goes on for a very long time.

The Order of Isshin Ryu. My karate family.

Yoshihito Sakimukai Sensei of the U.S.A. Jodo Federation and Andy Rodriquez Sensei, and all of the members of So Budo Kai. It is a privilege to train in Shindo Muso-Ryu Jodo with all of you. My journey into this incredible martial art will continue for a very long time.

Chuck Duarte and his wife, Emma, for providing the translation for Kim Sensei's work in plate #5 – Poetry by Yagyu Jubei. Chuck and Emma are wonderful friends whose company always lifts everyone's spirits.

A very special THANK YOU to Charlie Deitterick for helping with various photos of Kim Sensei within the book, and to his wife, Deanie, for her tireless work in editing and proofreading the manuscript. Many errors were caught by her keen eye. I am forever indebted.

Finally, I need to highlight the following art galleries that have been tremendously instrumental in my development as a Shodo artist – and have all graciously supported my efforts in a variety of ways:

Some Saturday Frame Shop (Harrisburg, PA / somesaturday.com). Stu Feeser, owner. I first met Stu around 1990 at his gallery in downtown Harrisburg, PA. I purchased a variety of art from his gallery. From there, Stu provided the framing for my Shodo art work. His experience with custom framing is second to none, as I receive nothing but the highest praise for the framing of my work. Without his friendship and support over the years, my art would have never seen the light of day.

Mulberry Art Studios (Lancaster, PA / mulberryartstudios.com). April Koppenhaver, owner. April has held two gallery exhibitions of my Shodo art at her studio (September 2009 and July 2010). Both shows were very successful and received good feedback from local press. Lancaster hosts First Friday gallery walks every month that are attended by visitors from New York, Philadelphia, and Baltimore. With over 90 art galleries within a five mile radius in downtown Lancaster, I am very proud of the reception my shows have received there.

New Beginnings Gallery (Lancaster, PA). Frank Thomas, owner. Frank was a visitor to my show in Lancaster, PA at Mulberry Art Studios. Afterward, he

requested my artwork to be added to his Japanese store permanently. New Beginnings offers bonsai, Japanese woodblock prints and various tea sets. I'm honored to be a part of Frank's gallery store.

Gallery at Second (Harrisburg, PA / galleryatsecond.com). Ted Walke, owner. I held a show at Ted's gallery in Harrisburg, PA in September 2012. This was a big step in my art career, considering the downtown location and how much Harrisburg is growing in the visual arts. Ted was a gracious host who has an interest in Japanese Shodo due to his prior experience with martial arts training.

TABLE OF CONTENTS

FORWARD

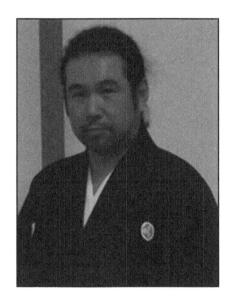

I have always believed that shodo and budo share a certain similarity of essence and application. This is particularly evidenced by the manner in which both arts emphasize the utmost importance of a single opportunity. . . building proper basics from the very beginning and viewing achievement as a lifelong journey rather than a thing of the moment. As Dan Popp Sensei puts it, "To reach a high level of understanding takes many years of committed, arduous practice and devotion." When comparing the two arts, shodo-ka (shodo student) and the budo-ka, they seem to be on the same path.

Dan Popp Sensei continues, "The paper is a life before him, with a single opportunity to be lived and therefore to be lived fully and meaningfully." From the perspective of a lifetime of budo-ka, "The Floating Brush" seems an entirely appropriate tool to evaluate my path in the martial arts. While reading this book, considering its meanings, and seeing it illustrated by the examples provided, I found myself evaluating my course of action and the direction of my life in budo. The affinity of one for the other was an epiphany for me, and I was eager to continue to the next page to study and wonder. This is certainly a path of a samurai.

Dan Popp Sensei and I became acquainted through the practice of Shindo Muso Ryu Jodo. On the first day we met, he mentioned to me that Jodo closely reminded him of kendo. I realize now, having read this book, that he was not just referring to kendo and Jodo, but more generally to the budo path in life. . . as it manifests itself in many different arts, including that of the brush.

I was not fortunate enough to have met Kim Sensei, but through this book, I felt that I was able to connect, in some small way, with his spirit and his budo. This book is, in a manner of speaking, a way to receive lessons from both Kim Sensei

and my own father today and into the future, despite the fact that they are both in the next life. I highly recommend that all martial artists read this book. It will now be a part of my training and required reading for all So Budo Kai yudansha. Arigatou Gozaimasu Sensei!

Yoshihito Sakimukai, SoShihan
So Budo Kai – Chintokan Martial Arts
Chintokan.com

INTRODUCTION

Shodo is the art of painting Japanese characters with a brush. Translated as "Way of the Brush," it is considered to be a high art form in the Orient and is becoming widely accepted within American culture. You can find examples of shodo sold almost anywhere in the United States today, most of which are either copies of the original or computer-generated replicas that make the cost of ownership possible for practically everyone. Regardless, people today are becoming inspired by these works of art, whether they are originals or lithographic prints. They are often conversation pieces within the American décor and are often used to add a level of calmness and serenity to the household.

Many of the books in print today offer excellent examples of shodo and are considered invaluable sources of information for explaining the art of shodo. The examples may have been brushed by Japanese of various backgrounds, including poets, painters, scholars, Zen monks, etc. This appears logical, since shodo is as old as the history of Japan itself. The various classes of people noted here used shodo as a creative way to convey the principles of their chosen following, such as Zen. You should note, however, that shodo was widely practiced by the samurai of ancient Japan, as well.

Many authors and historians have written at length on how the samurai migrated to the various cultural aesthetics of the day, such as the tea ceremony or Chado. Included in the list of "arts" that the samurai inevitably studied during their lifetime is shodo (way of the brush). Considering the samurai faced the potential of death nearly every day of their lives, they sought these "ways" as an outlet to cultivate inner peace, to find meaning in life beyond the sword. Dave Lowry writes in his book *Sword and Brush,* "For the samurai, encounters with art served as both a means of distracting him from the specter of death that accompanied him at every moment and a forum that allowed him to focus more pointedly on that death."

The execution and mind-set of these other art forms correlate closely to that of the martial arts. The practitioner of all these art forms must develop the proper combination of body, mind, and spirit in order to develop the control that is required to demonstrate these forms as they were intended (including martial

arts). When these art forms are demonstrated by a practitioner with a high level of skill, the end result is fascinating to watch and highly appreciated.

Samurai sought out masters of the brush for instruction. William Scott Wilson's book *The Lone Samurai* is the story of Miyamoto Musashi, who was considered the greatest Japanese swordsman of all time. His book provides discussion and examples of Musashi's shodo skills. John Stevens' book *The Sword of No Sword* provides the story of the martial arts and shodo skills of Yamaoka Tesshu (1836 - 1888), a swordsman of more recent times. The shodo skills learned in the days of the samurai were passed down from teacher to student, and the tradition continues to this day. Following the era of the samurai in Japan, many followers and leaders of the martial arts painted calligraphic pieces to inspire and instruct their disciples. Several famous sayings can be said of shodo or Japanese calligraphy, including, "calligraphy is the person" or "shodo is a picture of the mind." John Stevens writes in his autobiography of Morihei Ueshiba[1], the founder of Aikido, the belief in the Orient is that "One lives on in his or her brushwork." Thus, many exponents of the martial arts have left behind legacies to their students in the form of their shodo brushwork. Various practitioners of budo, or martial arts, have been noted as being highly involved in shodo, but few texts have been published to display these historical examples of this art form.

The New York Metropolitan Museum of Art held an exhibition of Chinese calligraphy from September 2000 through January 2001 titled, *The Embodied Image –Chinese Calligraphy from the John B. Elliott Collection*[2]. This particular showing of calligraphy as an art form was probably the largest and finest on exhibit outside of Asia, spanning the period from the inception of writing as a fine art in the fourth century to the modern era. Among the works presented were more than fifty-five hanging scrolls, hand scrolls, and album leaves from the Elliott collection.

During my visit, I was particularly drawn to one scroll that was painted by a Chinese martial artist during the period presented. The work had an intense dynamic of brushwork, and it seemed the spirit of the artist remained well-preserved. For some reason, the work seemed as if it had been brushed the day before.

[1] Abundant Peace: The Biography of Morihei Ueshiba, by John Stevens, ©1987, Shambhala Publications, Inc.

[2] The Embodied Image: Chinese Calligraphy from the John B. Elliott Collection, ©1999 by the Trustees of Princeton University. Published by The Art Museum, Princeton University.

The execution of shodo as an art form is quite similar to the performance of the martial arts with respect to breathing, relaxation, muscle control, and so forth. As I viewed this particular piece of art, I tried to imagine all of these factors in the execution of the brush and ink onto the paper. This can be the power, and quite possibly the goal, of art at a high level, whether it is shodo, oil or acrylic painting, music, sculpture, etc., to take the viewer of the art into the heart and mind of the artist.

This book provides a glimpse of the shodo work as executed by a modern master of martial arts. Duk Yeong Kim was a master of kendo (a system of swordsmanship modified over hundreds of years descending from the age of the samurai. Current practitioners utilize both a bamboo stick (shinai) and a wooden sword (bokken) in their practice.) and shodo and was trained in both disciplines for nearly seventy years. Although he was Korean by birth, Kim Sensei spent a considerable amount of time training and learning both kendo and shodo in Japan. He was my instructor in shodo and kendo simultaneously, and I feel this was not by accident. I believe his intent was to teach both art forms to me in an effort to demonstrate the correlation of the mind, body, and spirit in both "ways."

This manuscript:
Offers the reader and viewer a sampling of shodo artwork. When simply viewed and appreciated, the book can serve as a way to relax the mind. . . a sort of "coffee table" resource.

Tells the story how a modern kendo master taught an American the "way of the brush."

Provides an explanation of the samples to correlate the meaning of the artwork shown with various concepts of the martial arts and other areas of life.

CHAPTER 1
THE ART OF SHODO

"Kendo is a way to discipline the human character through the application of the principles of the katana."
— **Toshiyuki Matsubara, Kendo 7th Dan**

In the days of the samurai in Japan, learning the proper use of the katana (long sword) inevitably strengthened the mind and character of the user. Beyond mere self-defense technique, the samurai observed strict principles on proper handling and care of the sword itself. Over a period of time, the sword eventually displayed the inner character that the swordsman tried to hone in the first place. This same philosophy can also be said for the art of shodo. Through the techniques and applications of the brush to paint Japanese kanji, students of shodo are able to discipline and polish their characters. Learning the art of shodo is not an endeavor to be taken lightly. It is an intricate art form that requires many years of trial-and-error and continuous practice under a qualified instructor.

Shodo has a very long history, and various texts have traced the historical perspective of this art form for centuries. In short, the use of pictographic writing (i.e. characters) dates back roughly to the 28th century B.C. in China. From there, this method of writing evolved and eventually made its way to Japan and other countries in the Orient. The cumulative skills of writers, poets, and artists in Japan eventually gave way to the creation of shodo.

In *Sword and Brush,* Dave Lowry writes that shodo was influenced by the philosophy of Zen by stating, ". . . the art of writing with brush and ink is a common metaphor for Zen thought. Once the brush has touched the paper, the ink cannot be retrieved. It cannot even be brushed over, for to try to cover a mistake in this clumsy way is instantly obvious in the finished product. The calligrapher

must concentrate and then throw himself completely into the execution of the kanji... The paper is a life before him with a single opportunity to be lived fully and meaningfully." What Mr. Lowry writes here are values highly important to Japanese culture. The seriousness of the mind when undertaking the practice of a particular "way" such as shodo or the tea ceremony is paramount. In order to practice in the correct manner, the process must contain the mental aspects described by Mr. Lowry. Only then can the student of shodo improve his or her overall abilities.

The Japanese characters (kanji) must be written in precise order. Thus, the student must memorize the proper sequence of hundreds of characters. Kanji must be practiced over and over to ensure proper balance of ink and background space, as well as the proper spacing between characters.

For those involved in karate, the learning process of shodo is similar to learning the traditional fighting forms called kata. When learning kata, the student must first memorize the fighting techniques in proper sequence. Under the close scrutiny of a qualified instructor, the student can progress to understanding the meaning (Oyo) of the various techniques within the kata. Over time, as the student continues to polish the kata movements, power and speed are added to the form. The student develops the critical aspects of controlled breathing and "seeing" the perceived opponent prior to movement and focuses on sound basics within the kata (e.g., stances, punches, kicks, balance, control). Eventually, the karate-ka begins to "own" the kata. The movements become reflexive, and there is no thought involved, just reaction. In essence, the practitioner's instincts become elevated to a high degree. To reach this level of performance takes many years of committed, arduous practice and devotion to the martial arts.

Learning the art of shodo is very similar to that of martial arts training. Obviously, the focus is very different, but the execution of the practice is similar. First, you learn how to hold the *fude* (brush), then how to add the ink. The angle of the brush to paper quickly becomes important. You will eventually learn the speed of the brush stroke and the amount of pressure from brush to paper. You will come to understand how important basics are to the continual study of shodo. Then, on top of all this, you must learn the requisite order of the brush strokes.

Another essential component of learning the art of shodo is proper breathing. When executing the brush stroke, it is imperative to exhale slowly so your movement with the brush is coordinated with your mind and body. This allows the

work to be full of energy. If you hold your breath, the movement will be restrictive and the result of your brushwork will be lifeless.

This holds true with any form of sporting activity. When a baseball player swings the bat or throws the ball, he is not holding his breath. When the tennis player is about to hit the ball or the basketball player takes a shot, they exhale during the precise action noted. In karate, punches and kicks are delivered with a forced exhalation of breath, so the technique has power. In shodo, air is expelled in a slow and controlled manner to allow the movement to be full of life and free floating.

Shodo can be thought of as a "picture of the artists' mind." Breathing reflects the mind and its condition at any given moment. When you are excited or nervous, your breathing becomes short and shallow. When you try to calm yourself, you take long, deep breaths. When you are in a relaxed state, your breathing is slow and even. Without a relaxed level of breathing, the execution of shodo becomes nearly impossible. A small glimpse of the artists' mind is reflected in the art.

All of these concepts become somewhat intimidating to learn at first, just like any martial art. With time and committed practice, you will gain confidence, and more and more kanji will be added to your repertoire. The requisite concept to be applied in proper shodo execution is the strengthening of focus, intensity, and concentration. If you can achieve this after many years of training in the basics of the art, then you will be able to express your creativity freely, with the result being a wonderful piece of artwork. Your entire "being" will be summoned to execute the brushwork, and the result will be an accurate mirror of your mind at that moment in time.

Over time, as in the martial arts, the shodo-ka is able to paint various kanji beyond mere basic brush strokes and create a genuine piece of art that is admired for its vitality and visual impact. In order to create such excellent calligraphy, the artist's mind must reach a higher level of spirituality through rigorous practice, which reveals deep insight into the art itself.

The same can be said of the martial arts. Those who reach the deeper meaning of their chosen martial art are able to demonstrate the "spiritual" qualities found in true budo. Little wonder the samurai of ancient Japan often gravitated to the various "ways" of their culture. . . Way of Tea (chado), Way of Flower Arrangement (kado), and Way of the Brush (shodo). The ties between these "ways" and the martial arts are clearly evident.

In my teaching of Isshin Ryu Karate, I enjoy relating the various concepts of martial arts to various other activities such as golf, tennis, baseball, and even music. Each activity requires a specific sequence, rhythm, pause of action, etc. Consider a baseball pitcher when he's throwing a good game. The announcers on television will speak frequently of how he's in a good rhythm. Watching closely, you will see the same actions prior to each pitch and the same tempo of motion. Tiger Woods, during a round of golf, becomes extremely self-absorbed in what he is doing at each shot. He slows himself deliberately so he can control his mind, breath, and body. The same holds true in the practice of shodo.

Music has an even greater degree of similarity. There are various musical styles, including jazz, classical, blues, country, and rock. To drill down further, jazz can be classified into big band, bebop, ragtime, fusion, smooth, etc. All of these styles of jazz are dependent on varying structures or forms.

The effects of proper music and calligraphy can have similar effects on the mind and soul. Both art forms marshal energy, attention, and effort toward an ultimately unattainable perfection, although that is the goal for which the artist strives. Musicians practice incessantly. They become caught up in a web of tension and strive to obtain perfection, yet they never quite get there. They sometimes become so consumed and self-absorbed in their pursuit that they tend to forget the other aspects of the music industry such as fellowship, business, positively affecting their audience, etc.

A music recording and a scroll are the sensory records of certain moments in time available for "reliving the moments" and evaluating them, criticizing them, and learning from them. Both are a window to the soul of the artist, yet they also touch the soul of the person exposed to the particular art form. Music is controlling and focusing movement and breath (wind instruments) to achieve a meaningful organization of sounds. The same is true for shodo. . . to control movement through appropriate calmness of mind and breath in order to achieve a visually balanced composition on paper.

In Jazz music, drummers often use brush sticks during their performances. The famous Jazz musician, Zutty Singleton, is often credited with this form of drumming. Once during a performance, his sticks were too loud for a particular gig, so he used fly swatters. Thus was born "brush playing." When brush playing, the drummer utilizes proper force and "flow" of the brush sticks to achieve the proper sound. If this is not accomplished, it will be clearly evident even to an untrained ear. The same holds true in shodo. Unless the proper level of force and

movement is used, the ink will result in a dull line within the kanji being brushed, and the product will appear "lifeless."

Jazz requires a high level of improvisation in order to be effective and appreciated. Many years of training in the basics of sound is required before the musician can venture outside of the "norm" and let his or her mind flow freely to create sounds that, in essence, come from the heart and soul of the artist.

The parallel with shodo is again noted. During my training under Kim Sensei, he produced many pieces of beautiful art, yet he always found time during practice sessions to brush very basic characters. He understood and exemplified the importance of practicing the basics, even at his high level of achievement.

THE TOOLS OF SHODO

BASIC:

There are several essential "tools" needed to learn and practice shodo. They are presented here to provide a visual reference for those who research and study this art form. You can purchase these tools through Oriental specialty stores in most major cities or through online websites. There is no need to purchase anything expensive, as less expensive materials will suit your requirements just fine. There are many items that you can use in your practice, i.e., paper weights (*bunchin*), brush holders (*fude-maki*), brush rests, and small water containers (*suiteki),* but you only *need* the following tools for basic shodo study and practice.

1. Brush *(Fude)*
2. Paper *(Kami)*
3. Ink *(Bokuju)*

Fude

The *fude* comes in various sizes and quality (shown below). The shaft of the brush is normally made of bamboo, with animal hairs inserted. New brushes are stiff and come to a point because the hairs are covered with a layer of diluted glue to protect them from damage prior to initial use. This layer of glue needs to be washed away before using the brush.

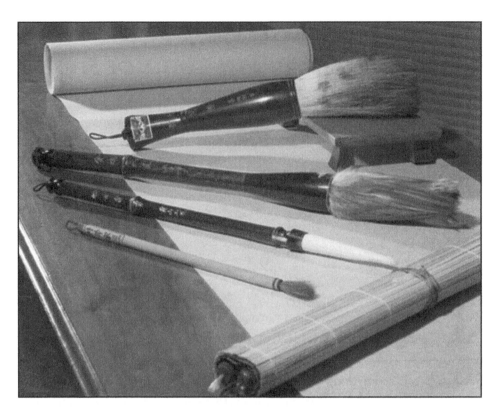

An assortment of shodo brushes – fude in Japanese

The brush hairs come with various hair types. White brushes are typically made from sheep or goat hair and are very good. Brown brushes are made with horse, wolf, or rabbit hair. The sizes of brush needed for beginning practice are *chu-fude* (medium-sized) and *ko-fude* (small-sized). Note the proper grip of the brush, as shown below. Notice how the brush is perpendicular at the beginning of each brush stroke. Shodo or calligraphy is written and reads from top to bottom and right to left.

After each practice session, you must clean the brush thoroughly. Run the brush under tap water and use a small amount of dish detergent, then hang to air dry. The saying is, "if the mind is correct, the brush will be correct." Part of this connectivity is having the discipline to maintain the brush at the highest level of care and respect to prevent a disconnect between mind and brush.

Think about how someone takes care of their equipment when they are fully committed to that activity. If you treat your tools with respect, they will perform well for you. My father is an avid long-range rifle competitor and hunter. He keeps

his rifles and equipment in excellent condition, cleaning them meticulously after every use. He once told me, "If you're not going to keep your equipment in excellent condition, why even think about practicing in the first place."

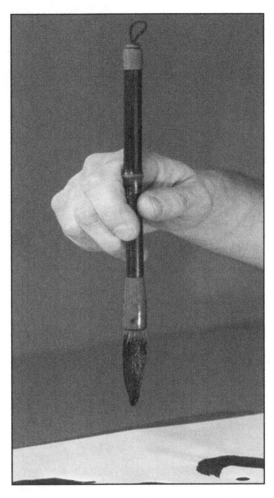

Proper way to hold the fude at the start of the brushstroke

When performing the brush stroke, it is imperative to hold the brush properly. Hold it somewhat like a pencil; however, your forefinger and thumb should not come to a point on the brush. Your thumb should point in a perpendicular direction to the brush hairs. The sequence of photos below of Kim Sensei shows how to handle the fude properly. Notice throughout the brushwork that the brush remains vertical and does not lean. This allows the bristles to snap back after each stroke.

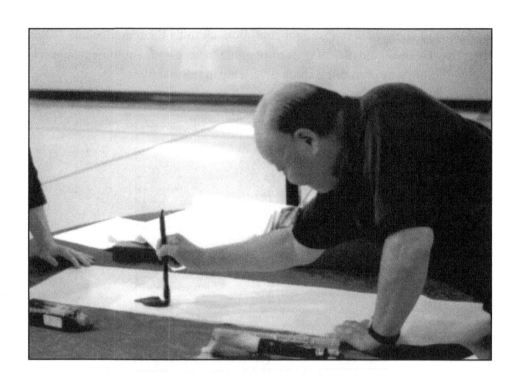

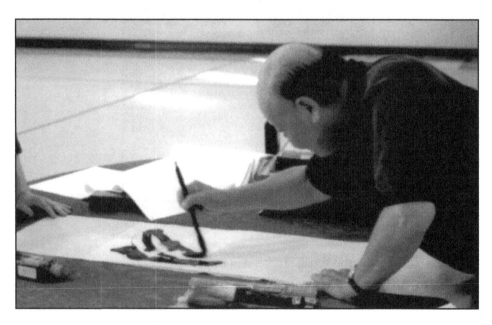

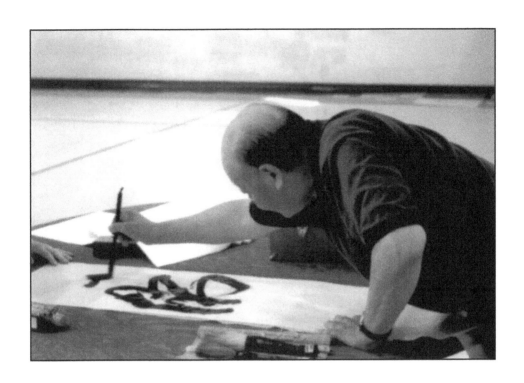

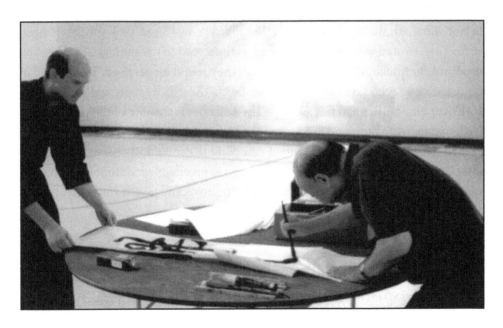

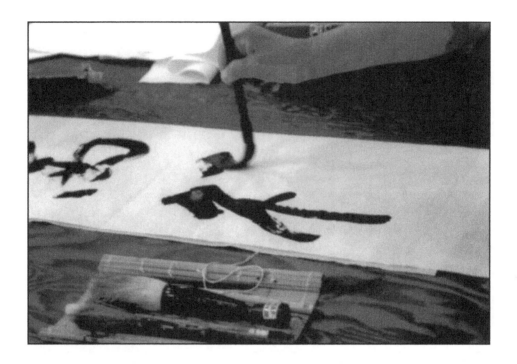

When brushes begin to show wear and tear, many followers of traditional shodo do not simply throw the brush away. The *fude* is considered very special, almost revered and treated with the same respect as the sword to the samurai. Brushes are saved and continually cared for, even though they are no longer used. This is similar to the karate-ka who saves all of his or her belts. Those belts represent all the hard work over time and should be cared for. The same holds true for kendo gear *(bogu)*, that becomes worn out or no longer fits. The bogu is not discarded, but is stored and cleaned occasionally. The bogu helped you build the skills and character you now possess, so in return you want to keep the bogu in excellent condition. In short, you honor the brush for helping you accomplish, improve, and polish your character.

Kami

Traditional kami is rice paper and generally comes in sheets of approximately 13 inches wide by 50 inches in length. The paper is extremely thin and delicate. Rice paper made by hand reveals small lines, as shown below. As with brushes, *kami (or washi)* comes in an assortment of sizes and quality. Knowledge of papermaking in Japan came by way of Korea, and the art was widespread by 770 A.D.

Rice paper used in shodo – kami in Japanese

Samples of shikishi and tanzaku

You can use newspaper as a substitute for practice because of its availability and absorbency of ink. It can also serve as a backing for the rice paper, since the ink bleeds easily through the rice paper during practice. The process of mounting rice paper to form the traditional hanging scroll, *kakejiku* or *kakemono,* is a very expensive process that requires specialized skills. As a student shodo, you can purchase pre-mounted rice paper scrolls, thus saving time and money.

Other forms of paper used in shodo, especially for gift purposes, include stiff pre-mounted paper, called *shikishi* (9.5 x 10.5 inches) and *tanzaku* (2 x 14 inches), that resembles ornate cardboard. Shikishi, meaning "beautiful leaf," is often used for writing *haiku* poetry. This type of paper is used frequently to brush gifts that commemorate various moments, such as the opening of a new business, presentation of a poem, an autograph, or bidding farewell or good luck. Kim Sensei presented me with a shikishi board in 2002, just after the birth of my second daughter. He brushed her name and date of birth on the board. Shikishi can be displayed individually or in sets to demonstrate a theme, such as the seasons of the year.

Shikishi demand grew considerably with the growth of poetry and literature during the Heian era (794 – 1185) in Japan. Considered the last division of "classical" Japanese history, the Heian period is known for its art. Coincidentally, this period is also noted for the rise of the samurai class in 1050. The Heian period is considered by many historians as the Renaissance period of Japan.

Shikishi comes in plain white or is decorated with various patterns from wavy muted colors to metallic speckles and is finished with gold or silver leaf edges. Tanzaku is the same as shikishi, only varying in its size.

Ink

Today's study of shodo offers the chance to use pre-made ink made from vegetable oil soot called *bokuju.* It is generally sold in twelve ounce bottles.

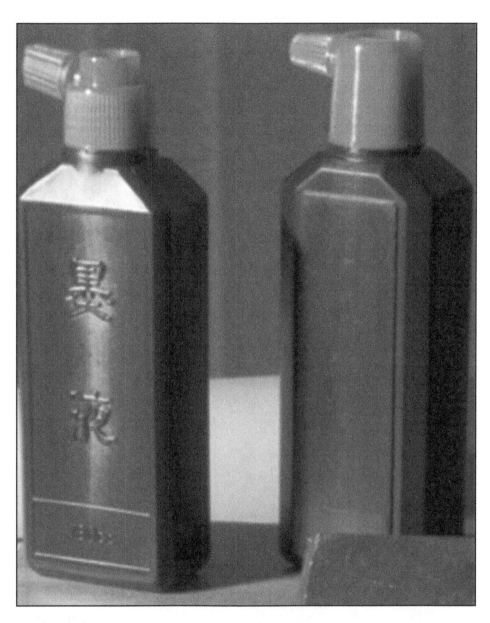

Bottles of pre-made shodo ink

ADVANCED:

The process of preparing ink by hand is a critical element of shodo practice. It gives the artist an opportunity to clear and calm the mind, a requirement that should never be overlooked in your practice. It is a meditative process prior to practice, a chance to rid the mind of all intrusions, distractions, and worry. Upon watching Kim Sensei grind his ink, there was no talk, no unnecessary action, no wandering of his focus. Only the simple, circular motion of ink and water until he felt the ink was ready to use.

Preparation of shodo ink by grinding ink stick onto suzuri stone

1. Ink stone *(Suzuri)*
2. Ink stick *(Sumi)*
3. Seal *(Hanko)*

Suzuri

Author's suzuri in the foreground; Kim sensei's suzuri in the background

The ink stone is generally carved from natural stone or slate and is used to mix and contain the ink. Most practitioners of shodo have *suzuri* of various sizes. The size is largely dependent on the amount of practice or brushwork to be

done at a particular time. The suzuri can be either a basic square-type shape or something more ornamental such as the one shown below. This suzuri was purchased by the author while vacationing in Macau. The other ink stone shown was a personal gift given to the author by his shodo sensei prior to his passing in 2007.

Sumi

Following the traditional practice of shodo requires the use of ink sticks. They were developed in China, and the manufacturing process has remained similar for over 1,000 years. Prior to this, it was discovered that ink could be produced from the residue of burnt wood. Today, soot from pine branches is combined with various natural oils such as vegetable or sesame. This is mixed with animal or fish glue, which is then molded and dried to form the rectangular shape known today. The ink stick is rubbed or grinded on end against the ink stone after adding a small amount of water to the stone. The use of the *sumi* in preparation of practicing your brushwork takes a fair degree of time and is somewhat laborious. The ardent practitioner views this process as an essential element of true shodo. The idea is to take the time to make your own ink and, during that time, let go of the tensions of the day to clear your mind of extraneous and provide the focus necessary to study the art of shodo in the manner in which it was intended.

Hanko

The seals affixed to shodo art are called *hanko*. Formally introduced in Japan in 701 A.D., hanko were generally for those with a high level of authority. Usage of the hanko in Japan is akin to signatures in the West. They are generally carved out of stone or wood and come in an assortment of shapes (e.g., square, rectangular, oval, circle) and sizes. In general, they contain the "signature" of the artist using a variety of kanji scripts. At other times the artist will affix another hanko that denotes other information such as school affiliation, a special meaning or proverb, motto, phrase, etc. The placement of the seal(s) is a matter of personal choice; however, the position of the seal should flow logically with the rest of the brushwork.

Hanko used by the author

Using these basic tools, shodo is conveyed through Brush Strokes

The act of brushing the various kanji is central to the practice of shodo. In music, everything that is required of the musician comes down to the actual sound that is produced. The listener then makes a judgment as to the quality of the sound. Quality music affects both the inside and outside of the listener. The same can be said of shodo. The only difference being music is generally appreciated by a "live" audience, while shodo is performed in solitude, then displayed and enjoyed by the audience at a later point in time.

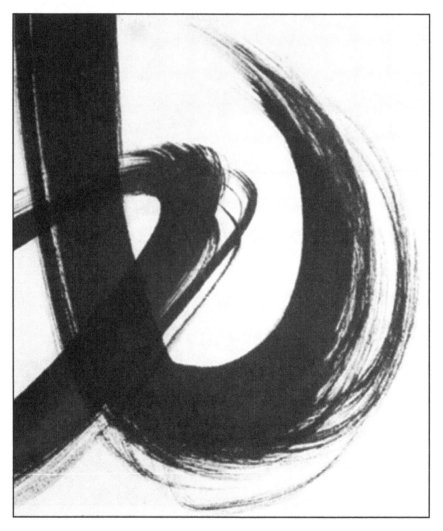

Kasure or 'flying white' brushstroke

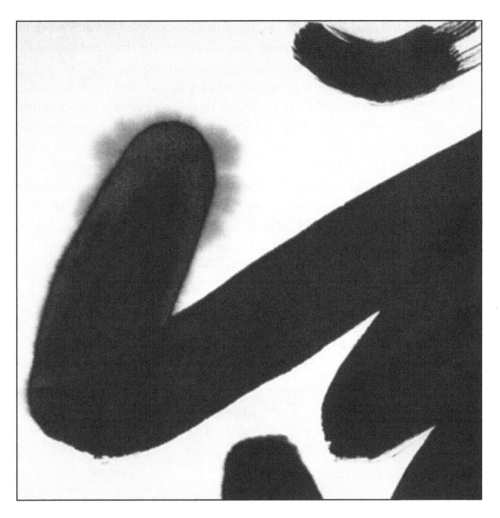

Nijimi brushstroke

The artist in shodo has various aspects of the final appearance to keep in mind during the brush stroke. All of these elements are controlled instantly as there is no such thing as covering up a mistake or getting a chance for a "do over." The artist must consider the size of the kanji based upon the composition to paint. The balance of all the kanji also comes into play, for a vertical piece that doesn't line up correctly will be obvious. The white space or negative space is factored into a quality piece of artwork. Quality shodo invites the viewer to consider the space in and around the character itself. The artist can enhance the overall appearance with the quality of the brush stroke by using either a dry, airy stroke (*kasure)* or one that appears to bleed

outside of the intended stroke (*nijimi*). These two brush strokes can add depth to the work and impact the viewer beyond simply looking at the characters, especially when considered with the context or description of the content.

I was unbelievably fortunate to have found a highly qualified instructor in the art of shodo, essentially in my own backyard. This is an extremely rare situation, as qualified instruction is difficult to find. However, this should not deter anyone who is intrigued and fascinated by this ancient Japanese art. Through repetition and focus, even those who travel the path of shodo without the personal guidance of a teacher can become quite adept. There are a fair number of excellent shodo artists in the world today who have never had lessons, or few lessons, in their life. Shodo is an enlightening art and should be available to anyone who wishes to learn and has the desire to persevere in their training.

CHAPTER 3

LEARNING SHODO

Duk Yeong (Reiun) Kim had a fascinating background. Kim Sensei was born December 12, 1926 in Seoul, South Korea and died May 30, 2007 at the age of 80. He began his study of kendo at the age of 12 in 1938. In his young adulthood, he traveled to Japan and worked with high ranking teachers there. His Sensei in Japan was Hukuoka Gorozaemon, a practitioner of the Niten Ichi Ryu style of swordsmanship, founded by Miyamoto Musashi. His Sensei trained extensively with a well-known exponent of the Mugai Ryu style of swordsmanship, Mochida Seiji. While Kim Sensei trained in Japan, he befriended many high quality exponents of kendo, including Teruyuki Matsubara, 8th Dan (degree) black belt. The friendship with Matsubara lasted the rest of his life and both communicated quite often. Kim Sensei consulted frequently with him on matters pertaining to kendo.

Reiun Kim attended the University of Seoul and entered the Korean military, eventually advancing to the rank of colonel in the South Korean Army. He moved to the United States in 1982 to attend the Virginia Quarter Master School. From there, he retired and moved his family to the Harrisburg, Pennsylvania area where he ran an Oriental furniture store for many years. During this time, Kim Sensei taught kendo to a select few students. Among those early students was Henry Smalls, a Harrisburg resident who later moved to Hawaii and became world famous as one of the few and quite possibly the only kendo-ka training without legs. He lost his legs as a child in a train accident and went on to represent the United States at the World Kendo Championships in Paris, France (1994) and Kyoto, Japan (1997) where he medaled in both Games. Just to have the chance to represent your country at these Championships is no small accomplishment. Doing so without the use of legs is simply incredible.

I met Kim Sensei in 1990. He was teaching a small number of kendo students at the karate dojo where I trained. One day I caught part of the lesson and was

impressed with the level of discipline required for training in kendo. Kim Sensei did not speak much during class. Rather, he instructed through his actions. I noticed that if the students didn't get the technique right, he made them "feel" why the technique was not correct. Kendo requires this type of feedback in order to fully understand how the body and mind must coordinate action to ensure proper technique and success. I was hooked and had to join the class.

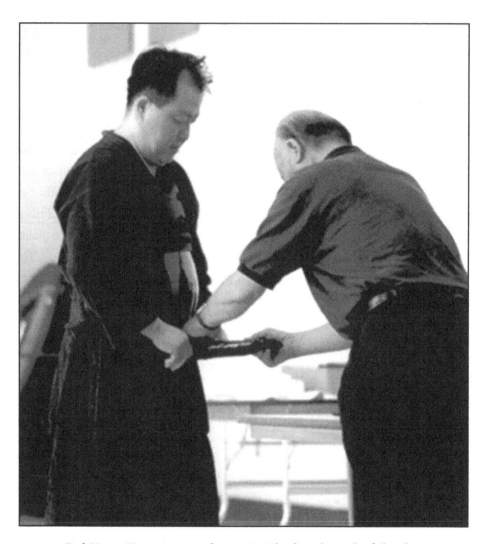

Duk Yeong Kim promoting his son, Michael, to the rank of Sho-dan (1st degree black belt) in kendo (April 2001). At such time, the kendo student's name is affixed to their waist protector called the Tare.

After about a month of small talk at the dojo before or after his kendo class, I made a visit to Kim Sensei at his apartment to formally request to become his student. Upon greeting me at his door, he simply pointed to my feet, which I understood to mean that I must remove my shoes prior to entering. I realized that he adhered to many of the Japanese traditions often read about in books about the founder of modern karate, Gichin Funakoshi, and the founder of aikido, Morihei Ueshiba. Shortly after sitting down, Sensei introduced his wife, who stood at the entrance to the kitchen and never entered the living room where Sensei and I talked. In fact, she never entered the room whenever Sensei had visiting kendo students. She respected his position as the kendo teacher. Fortunately, Mrs. Kim soon began to stay in the room when I was the only visitor.

During my initial visit, I got right to the point. I asked Sensei if I could begin training under him in kendo. His response was simply, "Ah, kendo many pain Popp-san. Many pain." My lack of understanding and inexperience came through as I replied, "Oh, I'm sure there is a lot of pain Sensei. I've seen how the students get hit during class! I'd still like to try it out though."

Sensei just chuckled a bit and said, "Okay, okay. Next Saturday, 8:30 am, dojo, you come." Little did I realize that the pain he was referring to wasn't merely physical pain, but also the pain of getting to the dojo at the assigned class times. Dealing with the pain of everyday problems, shutting them out during class, and focusing on the matter at hand. The commitment of being available to my Sensei whenever he needed me and adjusting my schedule accordingly.

These things are mandatory for all true students of kendo. In general, you must fully commit when training with a true master of the Japanese martial arts. In order to learn these arts appropriately as far as Eastern thought is concerned, it must have a proper place in your life. It must come first, right along with family.

Any form of laziness or lack of commitment is not tolerated. In our culture, it becomes easy to tell yourself that "it can wait another day," or "I just don't have the time for that today." Both of these thoughts are not good enough for learning kendo or shodo, and Kim Sensei let me know that in no small terms. Enduring this type of "pain" was more or less what Sensei meant during our first visit.

I went on during our conversation to ask about the calligraphy hanging in his apartment. I noticed the brushes, ink stone, and various calligraphy textbooks on a nearby table, and Sensei indicated that he practiced the art regularly. I told him I was interested in learning this Japanese art as well, asked if could he teach me shodo as well. Again, he just chuckled a bit. I tried to gain his confidence in my

interest by using words appropriate to the craft. I asked him how many kanji there are in shodo. He said, "Many, many." I went on to ask how much practice would be required to produce the type of artwork I saw on the walls of his apartment. Again he replied, "Many, many." As much as I tried, he wouldn't say if he would teach me calligraphy.

I wouldn't give up in my attempts to learn shodo. A few weeks later, I tried again. After a little research into some basic kanji, I was prepared to demonstrate to Sensei that I was serious in my request. As he was leaving the dojo after kendo class, I caught his attention and said, "Sensei, come watch." I wrote a simple horizontal line on a piece of paper.

He responded with simply, "Ichi" (or one). I then drew two horizontal lines one on top of the other. He then responded, "Ni" (or two). The same thing with the number three. At this point, my command of the Japanese language was exhausted, so I asked Sensei if he could write the numbers four through ten for me.

He seemed happy that I took the time to at least show an interest in learning Japanese, so I again requested to learn shodo. He finally relented and informed me that we could practice shodo prior to kendo lessons. This meant that I needed to get to the dojo by 7:30 am, instead of the previously agreed 8:30 am. I didn't mind though. This was my chance to learn two ancient Japanese art forms from a modern day master!

Kim Sensei's style of teaching was very much hands on, with little discussion or explanation. Language was a barrier to detailed explanations, but he also wanted me to feel the appropriate action. Kim Sensei was Korean, teaching Japanese arts such as kendo and shodo. Due to his extensive time training in Japan, it seemed as though he preferred teaching Japanese kendo as opposed to the Korean equivalent, kumdo. During kendo training sessions, I knew a block was incorrect as I was hit. A strike was ineffective when I either missed completely, or was jammed during my motion.

But more importantly, I could sense my opponent's intentions through the pressure applied to my shinai (training stick). Much like wrestlers can sense the opponent's next move based upon a shift in weight or strength, kendo students can develop an acute awareness of the next move based upon the pressure applied against shinai. This was Sensei's favorite way to teach. Unless I developed that "sense," I could not grasp the essence of kendo training.

Kim Sensei's hands-on teaching style also applied to his instruction in shodo. He was not as much concerned with my abilities to pick up the Japanese language or learn every kanji, as he was with transmitting to me the "sense" or "feel" with the brush.

Since he was around 65 years old in beginning my instruction and I was somewhat of advanced age in beginning my attempt of the study of shodo at 26, he was more interested in passing on the proper brush strokes in terms of pressure applied to the brush and the appropriate tempo in brushing certain types of strokes.

If this "sense" could be learned, then I could carry on the study of learning the kanji on my own using various training materials available today. Kim Sensei would put the brush in my hand, stand right next to me, put his hand over mine, and "lead" my hand through the proper brush sequence. He never said as much, but I knew precisely what he was doing. I took mental note of the various intangibles of pressure, angles, speed, application of ink to the brush, etc.

In the early portion of my shodo instruction, Sensei would brush a sample of basic kanji across the top of a practice sheet. For example, he would brush such characters as water, wind, cloud, and moon. I was required to watch him intently from the way he loaded the brush with ink to the order of the brushstrokes. He would then hand me a brush and have me repeat the characters moving down the page.

Sometimes he would watch as I made my attempt at copying his samples, called *tehon*. He would critique my work as I went, adding to the anxiety of the endeavor. To have a master of the brush watch your every move is somewhat intimidating.

Kim Sensei was a very patient and caring instructor. He knew I could not speak the language or read the kanji fluently, but I was a respectful and eager student. In Kim Sensei's mind, that was all I needed to learn and appreciate the art form I was being taught. Sometimes after brushing the samples for me, he would walk away and begin teaching kendo to the students who had arrived for lessons that day. I was left to my own devices to try and remember the brushstroke order. Sensei would return after a few minutes and correct my mistakes. He would either demonstrate the proper technique again or would hold my hand and "guide" me through the proper motion, showing me the correct pressure and speed of each brushstroke.

Then lessons continued in this fashion. Sensei brushed the samples or tehon, and I would attempt to duplicate the kanji. He would make corrections, and I made more attempts to brush correctly. Sensei would change up the samples for each lesson, gradually providing more and more complex kanji. He still included several of most basic characters to reinforce the need to ensure my basic skills were sound. This is a principle inherent in the traditional martial arts as well, to ensure basics are always practiced to remain well-grounded in the art. From time to time, the lessons required me to simply watch Sensei as he performed shodo

to varying degrees of difficulty. This is a learning method often overlooked, espe-cially in the martial arts. Students become so preoccupied in trying to mimic or duplicate their instructor's motions that they miss the intricate details. To pick up on them, you need to stand back and observe closely, watching for the minutiae.

Sensei brushed everything from a small, simple character to large scrolls (as seen throughout this book). I tried not to become too overwhelmed with the end result, which are obviously very impressive. I tried instead to notice his body motion, his breathing, his demeanor, and his action after finishing the work. In martial arts or other sports, this could be referred to as the "follow through." Sen-sei never rushed to the next piece of paper. Rather, he stepped back and "took in" what he had just brushed. He often shook his head as if he was disappointed with himself. To me, the brushwork was incredible! To him, being a perfectionist, he was never satisfied. At the same time, I believe, he was trying to convey to me the lesson of always striving to improve my work, no matter how it might look to someone else.

THE SHODO OF REIUN KIM

During my fifteen years training under Kim Sensei, I collected over 200 pieces of his shodo artwork. I've included 27 of them here for your enjoyment. Of those, Sensei signed just over half. It was difficult to get him to sign his work. He was never satisfied and always strived to improve himself, even at his advanced age. After he brushed a particular scroll, I would say to him, "Oh, very good Sensei. Maybe we should take this to the Philadelphia museum!" He would shake his head and reply, "No, no. Now, trash can go."

He was joking of course. But he didn't want the focus to be on him, but rather on the correct *process* of executing shodo. He never wanted me to overlook the crucial element of what I was learning. He wanted me to stay within the process rather than focus my attention on the final product. He knew that I would only be able to improve by keeping the proper mindset needed for shodo practice. That mindset requires me to remain humble, never be satisfied, and always strive to improve my work.

The following pages depict the high quality of Kim Sensei's brushwork. He was a true master in every sense of the word. Yet he continued to practice in the most unassuming and humble way imaginable. This made him the true

master that he was. For his kendo students, he provided the following nine steps to improve the mind in daily practice. He used the analogy of a sword for this list, but I also feel these things can be applied to all areas of life, including the practice of shodo.

Despair	Cut
Laziness	Cut
Dirtiness	Cut
Immortality	Cut
Discord	Cut
Irresponsibility	Cut
Haughty	Cut
Degeneration	Cut
Luxury	Cut

In other words, cut these things or afflictions out of your mind and ultimately your life. Only then can you honestly live a true and happy life.

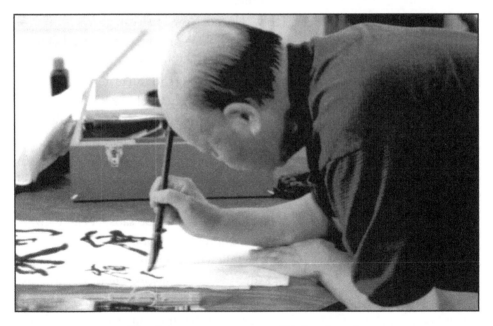

Kim Sensei signing a piece of his brushwork.
A rare moment in the author's learning of shodo

#1 - Title:	**Jiki Shin Kore Dojo**
Translation:	Direct mind is the place to practice
Specifications:	Ink on rice paper (13.5" x 45") Brushed March 2004

In the book *Moving Toward Stillness*,[3] author Dave Lowry explains that the word jiki is a rather simple translation. It means "directly," or "immediately," or "without delay." Thus, jikishin means "direct mind." Martial artists seek to respond to various situations within the dojo (training hall) as directly and efficiently as possible. This applies to the more advanced students only after many years of rigorous training in the basic techniques. There is no time to think about which technique is the best to deploy against a specific attack. The reaction must be automatic, and the student must face the attack directly.

The concept of "direct mind" carries such importance in the martial arts that jikishin is even used within the name of various styles of swordsmanship. One example is the Jikishinkage Ryu style. This system was founded at the Kashima Shrine by Matsumoto Bizen-no-Kami Naokatsu (1467–1524) and is a descendant of sword styles developed in the late Muromachi period of Japanese history. The Muromachi period (1336–1573) marks the governance of the Muromachi or Ashikaga shogunate, established by the first Muromachi shogun Ashikaga Takauji. The period ended in 1573 when the 15th and last shogun Ashikaga Yoshiaki was driven out of the capital in Kyoto by the famous military general Oda Nobunaga.

Research into the jikishinkage style of swordsmanship notes that through repetitive practice, the student strives toward an unwavering intention (jikishin) and a perfect clarity of the mind (seimeishin). As such, the student strives to attain an "immovable heart and mind," also referred to as fudoshin. One of the ideals that modern kendo students strive to attain is *jikishin,* or the level whereby the mind has perfect clarity and the reaction is automatic and direct. Although this concept may not be discussed often within current styles of karate, the level of jikishin, or direct mind, is expressed by those practitioners who have reached the highest levels of rank and insight into their respective karate style.

[3] Tuttle Publishing, copyright 2000 by Dave Lowry.

The concept of jikishin also applies or holds true with situations encountered in everyday life. As a martial artist, you should always strive to handle a given task or problem directly. You should never look for the easy answer. Approach each problem head on and use perseverance to solve problems or answer difficult situations rather than rely on others to make life easier. This is an example of "direct mind."

During a difficult time in my own life, I tried to explain to Kim Sensei why I couldn't operate my karate dojo (school). I gave him many of excuses, hoping he would have sympathy with my situation. I talked in circles because he didn't appear to buy any of it. Finally, while I was in mid-sentence, he gently rested his hand on my arm and said, "Popp-san, your life is your dojo." In other words, he was telling me that my mind was in the wrong place. I was trying to get around my responsibilities and provide excuses to justify my actions. Instead, my mind should have been focused on meeting my problems straight on with jikishin, rather than worry about upsetting Kim Sensei about not being able to teach.

He knew that my schedule and everything I was going through prevented me from teaching; thus, the things keeping me from teaching *were* in reality my dojo. This concept of *your life is your dojo* is presented in the book, Aikido for Life[4], by Gaku Homma. In Japanese, this is referred to as *Hobo Kore Dojo*. Mr. Homma calls various problems or barriers that we face in daily life as "walls." We tend to react to problems in our lives (i.e. walls) with frustration, avoidance, or whatever we can do to "get around" them. He suggests that if we can accept these walls as teachers and learn from them, then our lives become our dojo.

Another way to look at the concept of jikishin is when you no longer worry about what others think of you or your accomplishments. This realization comes at different times for everyone. Often, a tragedy in your life helps speed up this process. As an example, I have a close friend who has recently beaten colon cancer. He is a fellow karate-ka who has been training in karate for over thirty years. He tells the story that when the doctor gave him the diagnosis, rather than focus on the potential outcome, he faced the problem head-on. He told himself, "This is the fight that I've been training for all these years in martial arts." He faced his situation using jikishin, direct mind. Instead of throwing punches and kicks, he used his mind to confront the enemy and learned everything he could about his illness. He did not merely hope someone would help him; rather, he fought the cancer himself with his own mind, and he won the ultimate fight!

[4] Copyright 1990 by Gaku Homma. Published by North Atlantic Books.

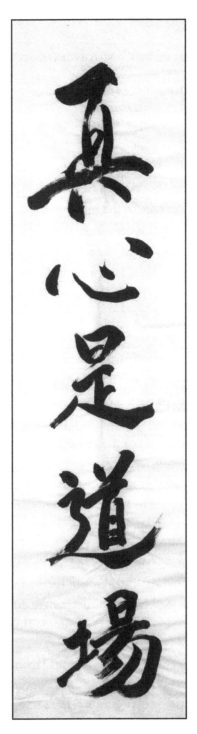

Jiki Shin Kore Dojo

#2 - Title:	**Ha Ki**
Translation:	Every day victory / Strive for victory each day
Specifications:	Ink on rice paper (13" x 43")
	Brushed October 2003

In this dramatic example of shodo, Kim Sensei's fighting spirit is exemplified. It is said that true calligraphers take to the brush in much the same manner as confronting an adversary. . . with the utmost of concentration, focus, and intensity. When Kim Sensei brushed this piece, his actions were animated and intense. Sensei exploded into a brush stroke with speed and power, then sort of trailed off into a softer motion during a change of direction or completion of a kanji. These actions are akin to kendo training, whereby the student in that particular discipline needs the same type of actions with his or her body and sword combined. Kendo-ka (kendo students) must learn to explode into an attack. They must also learn to softly evade or re-direct oncoming strikes. Finally, the completion of a technique in kendo concludes with a relaxed state of mind for proper focus and attentiveness. All of these actions from kendo training occur within fractions of a second. Kim Sensei harnessed all of the requisite actions (hard and soft) within this particular piece of artwork.

There is a generous usage of airy brush strokes, called *kasure* used in this example. Many people are used to kanji, which are completely black and easy to view. Kasure is actually highly appreciated and respected by those with a deep understanding of shodo. Notice how even or balanced Kim Sensei's use of kasure comes out in the overall composition. Several of the lines contain a fair degree of kasure mid-way through the brush stroke, but then conclude with enough ink to complete the brush stroke legibly. This is extremely difficult to do as the proper amount of pressure and speed of brush is required. This quality comes only after many years of practice.

This artwork is reminiscent of another famous Japanese swordsman, Miyamoto Musashi. In William Scott Wilson's book, *The Lone Samurai*, the shodo example of Musashi's "Spirit of Battle" provides much the same style as this example. The brush strokes are thick and bold, without any hesitation or doubt in the mind of

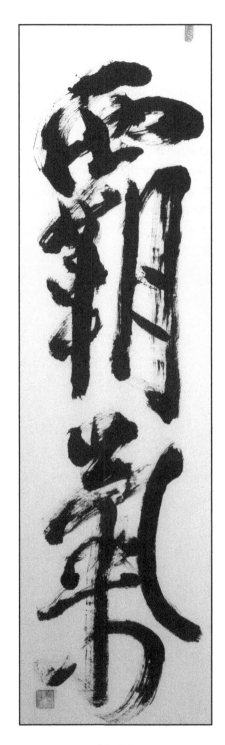

Ha Ki

the artist. Considering the context of Musashi's example in Wilson's book, the viewer can understand and appreciate the usage of kasure in the final product. Wilson says, "The goal of shodo is to express the visual meaning of each character in a way that is both beautiful and significant and manifests the artist's intent or state of mind."[5]

Kim Sensei often stated, "Life many difficult Popp-san." Each day provides many challenges, some small and some large. The martial artist should strive to meet them head-on and not look for shortcuts or the easy way around them. Each day is a small victory. The state of mind that is conveyed in this example is to face every day head-on, with the intent to win at whatever you face.

[5] William Scott Wilson, *The Lone Samurai: The Life of Miyamoto Musashi*, Kodansha International, copyright 2004

#3 - Title: **Nin**

Translation: Endure

Specifications: Ink on shikishi board (9.5" x 10.5")
 Brushed Feb. 2002

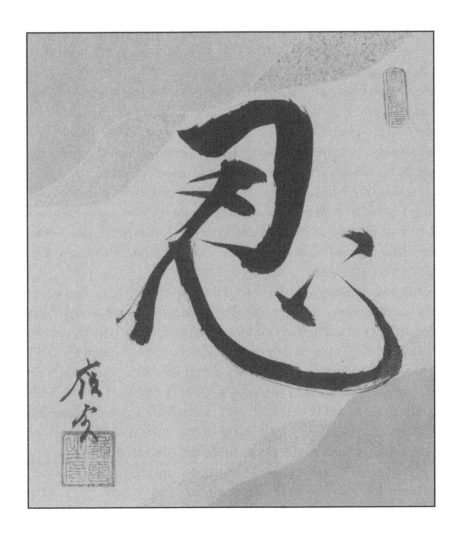

Brushed on *shikishi*, nin means to endure. Shikishi are thick, pre-mounted paper that can be framed or attached to a wall hanging. Usually has a gold-colored border;

the paper is generally 9.5 inches by 10.5 inches and can be either white or can have various colored backgrounds like the example provided here. Due to the small size of the paper, shikishi are often given as gifts to commemorate a special occasion such as a wedding, birth of a child, or maybe as a 'thank you' for helping a friend.

This piece was given to me by Kim Sensei at my 3rd Dan (degree) black belt promotion for kendo. Sensei explained to me that my training would become very difficult after 3rd Dan. Not only would the techniques become more difficult, but other areas of training would be as well. Lower-ranked students would begin to look more and more toward my guidance to help them along the path of learning. Thus, I would need to ensure my training did not slacken in any manner. Whether I wanted to or not, my teaching responsibilities would increase.

Getting myself to kendo practice early on Saturday mornings would become even harder. As the training progresses, the responsibility to train harder, and the time devoted to research increases. At this crossroads, people tend to slack off. After all, who wants to spend the beginning of their hard-earned weekend getting smacked by a bamboo stick? The excuses come more frequently.

This is a mistake. In essence, the learning of kendo calls for you, as a kendo-ka, to simply endure. Many hardships are endured along the way. The training is rigorous, and the physical and mental challenges are a constant reminder that you can never let up in your training. However, if you can endure such hardships, the rewards are very gratifying.

Now that Kim Sensei has passed on, I find myself seeing nin in a whole new light. I am trying my best to honor him by training as hard as I can and following his philosophies and teachings to the best of my abilities. He is no longer available for me to ask questions or to demonstrate a particular technique over and over again. Not only at the dojo, but also in my daily life, nin is important for me to demonstrate. Kim Sensei was a very calm and caring person. He always took time to listen to his students in both good times and bad. He was very patient. He discussed the intricacies of kendo and shodo over and over until I understood. He knew the language barrier between us made this process difficult, but he never gave up or wavered. He believed in all his students and their abilities to eventually "get it." He endured as only a true teacher can.

I find myself working hard to follow Kim Sensei's examples. I need to endure, as Sensei is no longer by my side to help guide me. I'm on my own now, to live up to all that he taught me.

#4 – Title:	**Yume**
Translation:	Dream
Specifications:	Ink on rice paper (12" x 12")
	Brushed February 2003

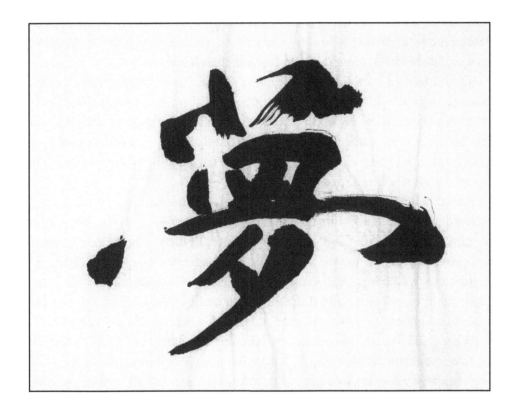

Dream is a popular topic for Zen calligraphy. Dream and awakening are thought of in conjunction with each other, and both states encompass Zen thought and research. The famous Zen monk, Takuan Soho (1573 – 1645) became the abbot of Daitokuji temple in Tokyo at 37 years of age. Although Takuan claimed no disciples, as he did not consider himself a teacher, he had many contemporary samurai who sought his advice on matters of Zen thought.

While he was on his death bed, his followers pleaded for his death poem. The practice of composing a death poem, or *jisei,* is a tradition rich in history of

many cultures throughout the world, especially Japan. The most common example is from the period of the samurai, whereby the samurai warrior composed a jisei during full ceremonial seppuku or ritual suicide. Poetry has always been an extremely important part of Japanese culture, as evidenced by various texts on the subject. *Renga* and *haiku* are two such examples of Japanese poetry, both with specific rules that must be followed. *Jisei* were brushed by poets, scholars, samurai, and monks for their followers as a sort of salutation or "farewell to life." The death poem, as in the practice of haiku, followed several constraints as well. For example, the mention of death itself in most cases was considered inappropriate. Rather, the focus of the jisei was on metaphoric references such as the change of seasons, falling leaves, growth of mind, or enlightenment, etc.

Takuan refused over and over to leave a *jisei* for his followers. After repeated requests, he finally gave in and simply brushed the character *yume,* or dream. Not exactly a *haiku* poem by any means; rather a single kanji was left to ponder. A poem may have been much easier for his followers to translate and perceive the underlying lesson within. Instead, he left but a single character, albeit in frustration for being repeatedly bothered in the first place.

A brief look at Takuan's life may provide an insight here to consider. He was an extraordinary Zen monk with a fascinating personality. He rose quickly through the ranks to become the head of a Zen monastery at the young age of 37, which was extremely rare. In today's society, we might refer to Takuan as a "natural." Research shows Takuan hated authority and power, and he not only turned down honorary titles, but also refused the Shogun himself when asked to serve under him. He sought out a simple existence and completely rejected power and fame.

What could Takuan have meant with the simple message of "dream?" According to our standards of life today, he led anything but a dreamy existence. We tend to place a high value on those things that help us get ahead in life. . . such as a high level of income, a nice house, expensive cars, the best computer, or flat screen television. We want to rise up the corporate ladder and not think twice about who will be affected by our actions. What about helping those less fortunate? What about continually striving for a higher level of education? What about pitching in to help our community become a better place to live? What about simply getting along better with our neighbors or friends? I believe Takuan wanted to point towards those "dreams" or goals. In other words, dream for a better tomorrow by focusing on the simpler things in life (i.e., betterment of yourself and those around you).

One message that I pass along to my karate students is. . . if you pay close attention to your Sensei during his or her lifetime, then you will understand how to proceed in your training and further development when he or she is no longer there. Thus, if Takuan's followers paid attention during his lifetime, then they should have understood what he meant by simply brushing *yume*. A full *haiku* was not needed to pass along to his students; a single kanji was all that was needed.

The example shown here was brushed when Kim Sensei was 76 years old. The kanji is extremely clear and balanced. His action was resolute and fully committed to the brushwork. This is one of my favorite pieces by my Sensei because of the simplicity of the topic. Quite simply – dream.

#5 – Title:	**Poetry by Yagyu Jubei**
Translation:	Furuto miba
	when you see the snow fall
	Tsumoranu uchi ni
	before it accumulates
	Harai kaku
	brush it off
	Yukii niwa orenu
	the snow will not break
	Aoyanagi no ito
	the young branches of the green willow

Strive to not break under pressure, but rather bend like the willow tree.

Specifications:	Ink on rice paper (13" x 44")
	Brushed 1999

This passage is credited to Yagyu Jubei (1607 – 1650), a famous master swords-man in Japan during the Edo period. Other than Miyamoto Musashi, Jubei's life is probably the most intriguing and romanticized of the samurai era of Japan. His fa-ther, Yagyu Munenori (1571-1645), founded the Yagyu Shinkage Ryu School of swordsmanship and became the fencing instructor to three successive Shoguns. . . Tokugawa Ieyasu, Hidetada, and Iemistu. Jubei himself eventually was appointed the sword instructor for the Third Tokugawa Shogun, Tokugawa Iemitsu.

The Yagyu clan had a long line of master swordsman, and Jubei was soon considered the best. However, accounts of his life note that he was extremely brash and, as a result, was dismissed by the Shogun for unknown reasons. For a period of time, he embarked on a warrior's pilgrimage or Musha Shugyo, and records of his whereabouts are scant at best. Yagyu Jubei is characterized in sto-ries and movies by an eye patch, and it is unclear just how he lost sight in one eye. Even his death is surrounded in speculation and mystery.

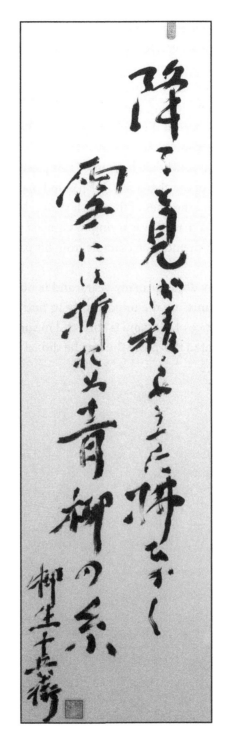

Poetry by Yagyu Jubei

This piece of shodo painted by Kim Sensei is particularly fascinating, as he did not use a *tehon* (sample) to paint it. Rather, he executed the brushwork entirely from memory, demonstrating an extremely high level of mastery of shodo. Another point of interest is that he didn't brush his own signature but rather brushed Jubei's name (lower left corner). When viewing the brushwork compared to other examples in this book (as well as others in the author's private collection), the kanji appear somewhat abbreviated or wobbly.

Kim Sensei was 73 years old when he painted this piece; however, age was not a factor for the appearance of the characters. He painted many pieces years later that had a high level of clarity in the lines of the brush stroke. My opinion for the visual appearance of this work is that he was trying to emulate the brushwork of Yagyu Jubei, going strictly on his memory of a sample from his past. How long ago is anyone's guess.

This piece hung in my dojo for many years, and is now in my office. When I look at it today, I regret missing the opportunity to find out from Kim Sensei if my guess on the appearance of the kanji is correct. I'm sure there was an excellent story behind why he painted this piece the way he did.

#6 – Title:	**Ken Ka**
Translation:	Powerful Sword
Specifications:	Ink on rice paper (13.5" x 42") Brushed June 2002

Kim Sensei explored various calligraphy works by ancient and contemporary artists. He instructed me to seek out as many examples as possible and respect what they had to offer. Sensei told me, "Popp-san, all good. Many styles. Many shodo man. You many research please." He wanted me to experience as much as I could with respect to what other shodo artists offered. In return, this would only heighten my appreciation of shodo and subsequent respect for what others have accomplished.

The plate above for Ken Ka is quite interesting. Sensei used a very old script for this brushwork. The character for *ken* (or sword), on the right is brushed using the Korean character for sword. Notice how he signed his name using a similar brush style as the main characters in order to balance the visual experience.

#7 – Title:	**Mool Tha Hae**
Translation:	Eliminate Pride and Arrogance.
Specifications:	Ink on rice paper (13.5" x 48")
Brushed October 2003 |

This is one of the few pieces that Kim Sensei signed. He painted the characters very large and bold. Kim Sensei liked this approach to his brushwork when the intent was to demonstrate the seriousness of the topic or to emphasize the importance of the message to be learned. Everyone who knew Duk Yeong Kim would agree that he valued this message considerably in his kendo students. Those who would disregard self-pride or personal achievement, personalities that would lead to arrogance, understood the ultimate aim of martial arts, and kendo in particular. Kim Sensei lived this "ideal" every day. He downplayed his achievements and humbled himself at all times.

Although the kanji painted here reflects a great deal of *kasure*, or airy strokes, the overall result is a very strong, committed mind that brushed this calligraphy. The shading of the brush stroke from dark to light is analogous to music notes. Shifting music notes from strong to soft brings the music to "life." The same is true of the brush stroke.

This overall composition appears to be more alive and flowing with the usage of various degrees of shading. Exponents of karate come to realize the same holds true in their training. The well-known "Code of Karate" contains a passage that reads: The law includes hardness and softness. Without a mixture of the two, whether speaking physically or mentally, the result of your particular endeavor will lack fullness and energy.

The action of the brushwork noted in the example above is deliberate and balanced. The traits shown in this brushwork are the result of a martial artist with over sixty years of experience. Although the message of this kanji may appear simple to understand, putting it into practice every day of your life is a different matter altogether.

#8 – Title: **Shi Sei Itt Kan**

Translation: One way

Specifications: Ink on rice paper (13.5" x 50")
 Brushed January 1998

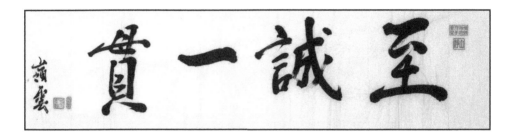

This piece was brushed to honor the opening of my first dojo in 1998. The dojo was rather small; however, Kim Sensei enjoyed the hardwood floors and the privacy of the space. We could only accommodate about four students during our kendo practice, but this only benefited the students as we came to know Sensei even better.

Because of the privacy of these sessions, Sensei tended to let his guard down and show us his more "human" side. I brought my oldest daughter, several months old at the time, to the dojo with me and set her up in a crib. After class, Sensei always took time to play with her. I enjoyed those moments thoroughly as I got a glimpse of a true kendo master demonstrating how gentle someone who trains in the budo should be.

When asked what the calligraphy meant, Sensei always responded very simply with, "one way, you mind." I pressed Sensei for more information from time-to-time on the meaning, and he always said, "Anything you do. . . karate, kendo, shodo, work, gardening. Only one way. You way, nobody else. Straight ahead. No shortcut. One way." That explanation pretty much sums it up. Press onward without losing your focus on the goal.

The following picture shows Kim Sensei in my first dojo, with the shodo shown above. He always demonstrated a quiet dignity in his photos, yet I observed the strength and confidence of a martial artist with years of advanced study.

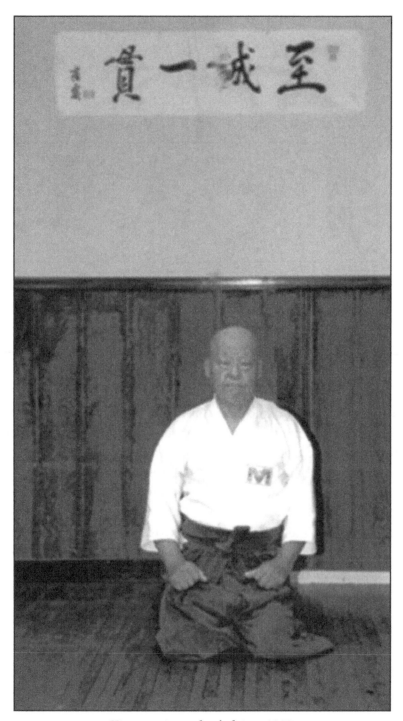

Kim sensei at author's dojo – 1998

#9 – Title:	**Nichi Nichi Kore Konichi**
Translation:	Every day is a good day
Specifications:	Ink on rice paper (13.5" x 48")
	Brushed April 2003

This expression is attributed to the legendary Chinese Zen monk Yunmen Wenyan (864 – 949). Commonly referred to his Japanese name of Ummon, he was a Zen master in the Tang era of China. Ummon was a pioneer of paradoxical statements that would later evolve into the traditional usage of *koans* or riddles that Zen monks contemplate in order to achieve enlightenment. He introduced in his teachings "one-word barriers" meant to spur insight and further realization.

One of his most famous stories tells where he addressed his assembly and stated, "I am not asking about the days before the fifteenth of the month. Tell me something of the other days." He provided the answer, "Every day is a good day." As such, this answer is a favorite Zen expression and is used quite frequently in shodo practice.

Kim Sensei not only enjoyed this expression, he "lived" it. The style of his instruction led me to believe this expression after every training session. I often took both of my daughters, when they were very young, to my kendo training sessions as I knew Kim Sensei would be thrilled to see them. He took time, after changing clothes, to play with them, talk with them, and give them a goodbye hug. When I watched Sensei at these times, the meaning of *Nichi Nichi Kore Konichi* rang loud and clear. Even during times of difficulty in the dojo, Sensei was able to show a caring heart and show me that I was doing just fine. Every day with Kim Sensei was a good day, for certain.

#10 – Title:	**Kendo Seishin**
Translation:	Kendo Spirit
Specifications:	Ink on rice paper (13.5" x 48") Brushed January 2002

Kendo was formalized around the end of WWII and is the modern version of kenjutsu, the budo studied by the samurai of ancient Japan. For the safety of practitioners, kendo was modified from its older ancestor. The major transformation was in the form of protective equipment.

Although training methods have become "modernized," the kendo-ka still attempts to follow a strict lifestyle. Kendo seishin is this "spirit" or lifestyle. Kim Sensei often referred to this aspect as "kendo man." He told his students, "No smoking, no drinking, honest, diligent, work hard, research, no argue, never give up; this kendo man." To Sensei, this was the true "kendo spirit." We can no longer prove our fighting spirit on the battlefield; thus, we need to turn inward and focus on self. Only with the proper "spirit" can we measure our worth over the long term.

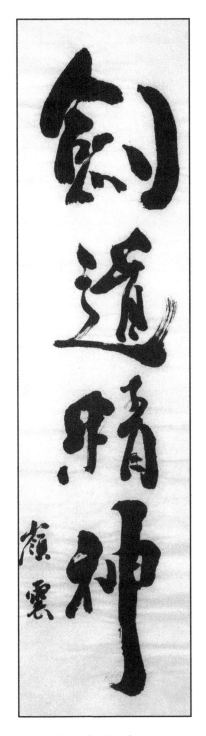

Kendo Seishin

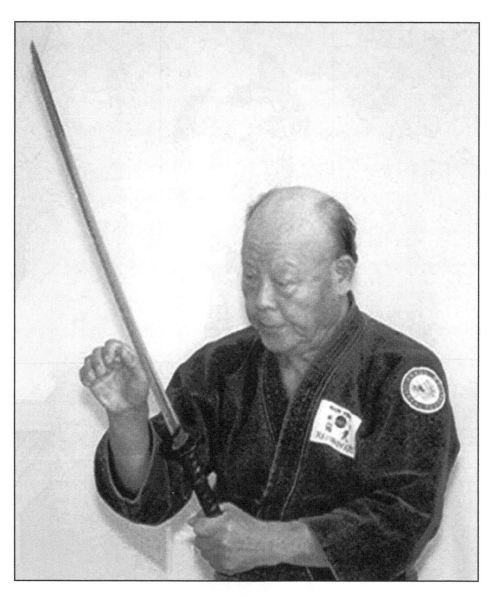

Kim Sensei providing instruction during kendo kata, or traditional forms

#11 – Title: **Kendo Seishin**

Translation: Kendo Spirit

Specifications: Ink on rice paper (13.5" x 50")
Brushed March 2003

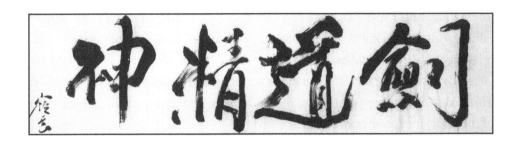

Another version of Kim Sensei's calligraphy is kendo seishin. This time, the kanji is read from right to left. It was brushed several years after the previous example, and you can see the level of confidence in the brushwork. From the example in the preceding plate, the characters are larger and more "airy." The term used in shodo to denote the "airiness" portion of the stroke is called *kasure*.

The style presented here is similar to that brushed by the founder of aikido, Morihei Ueshiba. Kim Sensei admired the work of many budo masters of the past, including ueshiba (aikido) and tesshu (kenjustsu) and used their *tehon*[6] within his own practice. Although Kim Sensei was advanced in his own right regarding the art of shodo, he always considered himself a beginner and worked to improve every day by trying to emulate the brushwork of other highly regarded artists. The piece above resembles the famous "aikido" example[7] by Ueshiba, who brushed with an almost playful style and let the characters develop on their own. This approach shines through in this example of kendo seishin.

[6] Tehon: example of calligraphy for the shodo student to copy in his practice.
[7] Abundant Peace, The Biography of Morihei Ueshiba, by John Stevens. Shambhala Publications, Inc. Copyright 1987

#12 – Title:	**Kokoro**
Translation:	Spirit
Specifications:	Ink on rice paper (11" x 11")
	Brushed May 2001

The formation of this kanji has several meanings, including "heart" or "mind" (shin), and "spirit" (kokoro). This particular kanji is also used in conjunction with other kanji, as shown earlier in plate #3 for nin. When used by itself, this character generally refers to spirit. The Japanese consider a proper spirit highly valuable. This is shown in all aspects of their life from the martial arts to the simplistic style of the interior of their homes.

Kokoro can be written in numerous styles. The cover art for this book shows a more traditional style whereby the three separate "dots" reflect the channels of the heart. In this example, Kim Sensei seems to emphasize the strength of proper spirit with brush strokes that are thicker than customary. Kim Sensei was a strong advocate for the proper "spirit" of the kendo-ka. He was more concerned with his students showing proper etiquette and respect towards others and the art of kendo. The "spirit" that he required was a giving mindset, honoring our sensei and fellow man, helping others without question or need for payment. These attributes are not always easy to demonstrate. We often become preoccupied with our own needs and wants. Kim Sensei held these traits, and many others along the same lines, in high regard. They were a major part of the training in becoming a "kendo man."

Although there are many different ways to brush this kanji, all should be legible to the observer.

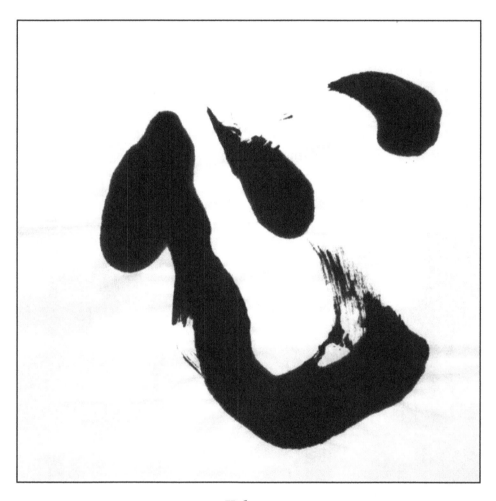

Kokoro

#13 – Title:	**Butsu Shin**
Translation:	Buddha mind
Specifications:	Ink on rice paper (13.5" x 43")
	Brushed February 1999

This calligraphy was another of Kim Sensei's favorites. He brushed this topic very quickly, without hesitation or thought. He became fairly "animated" during the brushwork for this topic, which is typical of most Zen calligraphers. The attempt to infuse the brushwork with the spirit of calligrapher is the intent. The photo below shows Kim Sensei brushing butsu shin during one of my shodo lessons. I am holding the paper at the top due to the level of pressure being applied to the brushwork.

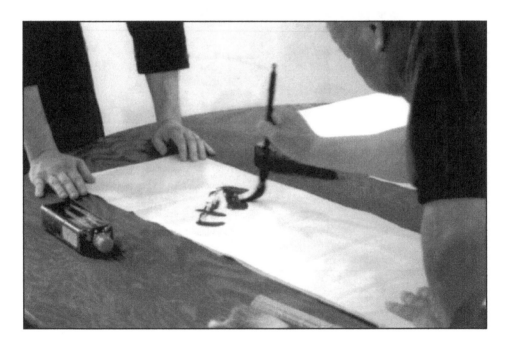

In the plate above, the level of spirit is shown as well. Again, the brushwork is immediate with the generous usage of kasure, or airy strokes. The piece is well-balanced, even in light of the speed of the brush, which shows proper control

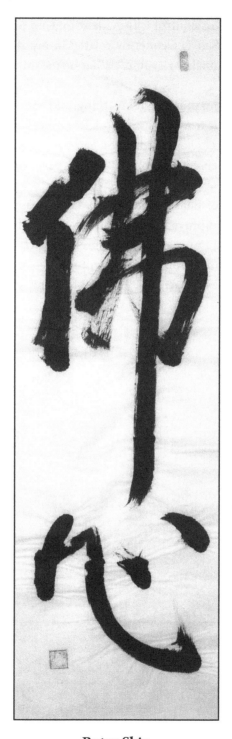

Butsu Shin

of the fude (brush). This control was evident by Kim Sensei while wielding a shinai or sword. Kim Sensei frequently related in my shodo practice, "Brush, shinai, bokken, punch, kick – all same." What he meant was the *control* of each of these actions.

If you can control your mind, your breathing, and your muscles then the result of your endeavors will be true and successful. Regardless of what you are doing or in whatever activity you are engaged, if you can control yourself mentally, physically, and spiritually, then your actions will be proper. . . and you will be satisfied with the result.

Another meaning of Sensei's motto "all same" was the requisite practice needed to advance or improve in skill. Unless you are willing to sacrifice a substantial amount of time and energy in your preferred activity (e.g. shodo, karate, kendo, or any other endeavor), then you will not be successful no matter how hard you try to control your actions. True control only comes after many years of committed practice.

#14 – Title: **Sui Getsu Ken**

Translation: Water / Moon / Sword

Specifications: Ink on rice paper (13.5" x 40")
 Brushed February 2003

Sui Getsu (water – moon) is a popular topic for Zen calligraphy. The meaning of sui getsu has direct relevance to martial artists of all styles. The idea is to calm the mind to the point of total control, even in the face of a life-threatening situation. This is similar to the reflection of the moon on the surface of a pond. When the pond is calm, the refection of the moonlight has perfect clarity, with no distortions. This is the goal of the martial artist and cannot even be approached without a significant amount of tireless training in the basics. You try to attain total calmness in order to have proper reflex action (reflected moonlight on water).

This calligraphic "topic" was also brushed by Yamaoka Tesshu, a famous swordsman from the late 1800's. John Stevens writes in his autobiography of Tesshu, *The Sword of No Sword*, "When the moon reveals itself, it is immediately reflected on the water, yet the moon does not consciously seek out water, and water makes no effort to hold the light. This reaction is spontaneous, in perfect natural accord. Such an unobstructed state of instant, untainted response is the ideal of both Zen and swordsmanship."

Kim Sensei enjoyed telling the story of Tsukahara Bokuden (1489 - 1571). Regarded as a kensei (sword saint), Bokuden eventually founded his own style of swordsmanship, kashima shinto-ryu. Sensei would explain that Bokuden would try to use his sword and make a cut into a pond without making a "rippling" effect to the water. This is something that is very difficult to do. Thus, Sensei would often add the k*en* (sword) to the end of this shodo topic during our practice sessions.

San Satsu: Kamae / Waza / Ki

Translation: Three Properties: Posture / Technique / Spirit

Specifications: Ink on rice paper (13.5" x 43")
Brushed April 2003

During his kendo teaching, Kim Sensei was fond of putting emphasis on the three properties or qualities that the kendo-ka should possess. He took it one step further and said that the order of importance was 1) eye or posture, 2) kiai[8] or spirit, and 3) technique. Emphasis is often placed on the person who has the best technique.

Who can punch the hardest? Who has won the most trophies? Whose technique is the fastest? Who can break the most boards? These questions focus primarily on the technique, or the physical aspect of martial arts. Kim Sensei purposefully focused on this aspect of training last. The focus in his teaching (both in and out of the dojo) was on proper posture and spirit. These two areas serve the martial artist the most. Proper posture and spirit are more lasting, serving the martial artist well into old age. Technique (physical attributes) tends to deteriorate over time, so Kim Sensei felt that posture and spirit were more important to grasp.

[8] Kiai is the "spirit shout" often heard during training. It is used to facilitate the release of energy during impact of a strike. Some relate this "shout" to that heard by professional tennis players when impacting the ball with their racquet.

From a purely combat standpoint, Kim Sensei taught that if you could control these three properties of your opponent, victory was certainly imminent. . . although not easy to put into practice. As mentioned earlier, most kendo-ka tend to focus purely on technique. However, it becomes equally important to improve your posture and spirit as you progress in your training. This holds true in whatever endeavor you confront.

Not only is the physical action important to understand and perfect, but also having proper posture (which includes hand/eye coordination, etc.) and proper spirit (frame of mind) becomes more and more essential as your skills become seasoned. The photo below provides an example of proper "posture," where Kim Sensei is demonstrating the gedan no kamae stance used in swordsmanship.

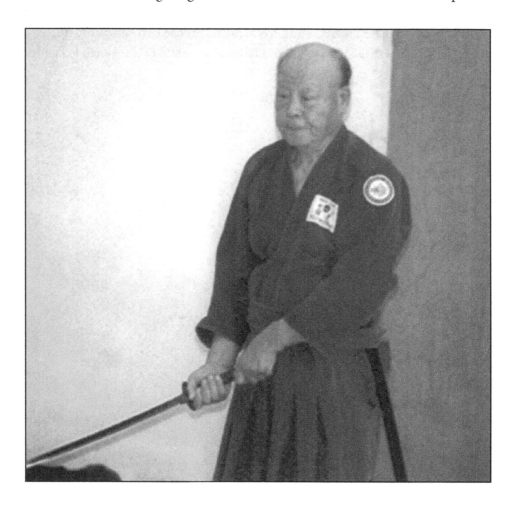

Hasso and gedan are two of the five basic stances used in kendo. Both postures and stances are utilized just prior to an attack or defense in kendo. Notice the calm nature of Kim Sensei. Although confronted with a potential attack, there is no noticeable excitement. The kendo-ka is able to demonstrate this necessary trait only after years and years of practice. This same level of calm is of paramount importance in the art of shodo as well. Unless the shodo-ka is able to remain absolutely calm just prior to the brush stroke, efforts will be in vain and the brushwork will lack any real "life" and will not accurately reflect the mind of the artist.

In kendo, when proper posture is combined with appropriate footwork, the kendo-ka's effectiveness elevates considerably. Footwork is often considered a form of technique, called *ashi sabaki.* Those who are highly skilled in budo such as kendo or karate can actually utilize footwork alone to overwhelm an opponent and ultimately achieve victory. Thus, footwork in a sense becomes more important than the actual strike with the sword (shinai) in kendo or the punch in karate.

#16 – Title:	**Shi Kai: Odoroku / Osoreru / Utagau / Madou**
Translation:	Four Sicknesses: Fear / Surprise / Doubt / Confusion
Specifications:	Ink on rice paper (13.5" x 43") Brushed April 2003

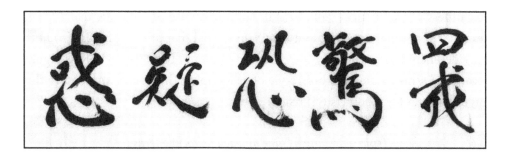

The samurai of Japan's feudal age were concerned with four "sicknesses," any one of which could afflict the mind of the warrior and lead to defeat. As such, the samurai trained tirelessly to avoid at all costs the sicknesses of fear, surprise, doubt and confusion. If any one of these entered the mind, the samurai faced an uphill battle.

We face the same "ills" today, and they hold us back and prevent us from reaching our necessary and desired objectives. The consequences will probably not result in death, as was the case for the samurai, be we can condition our minds through dedicated training to address these "sicknesses" and handle them as necessary to improve our everyday lives and help us reach our life goals.

#17 – Title:	**Tsuki w/Poetry**
Translation:	Moon
Specifications:	Ink on rice paper (13.5" x 42")
	Brushed April 2003

Regardless of experience, rank, or skill level, it is wise to continue using *tehon* (examples) of other artists. . . and Kim Sensei lived that philosophy. The subject provided here was brushed by the Zen monk Jiun (1718-1804), who was highly regarded for his natural and bold style of calligraphy. The poetry attached to the large character for moon (tsuki) reads:

Tenjo senmannen tsune ni waga kokochi o terasu
The moon in the heavens for millions of years, always illuminating our minds

This work can also be found within John Stevens' *Sacred Calligraphy of the East*[9]. The book presents Jiun's work, which incorporated a preferred dry, airy brushstroke. The sample in Mr. Stevens' book shows each character brushed separate of one another. Here, Kim Sensei uses a clean, flowing style within the poetry itself. The characters seem to run together. Kim Sensei brushed this piece rather quickly, without even looking at the *tehon*. Rather, he produced the piece from memory and demonstrated his excellent control of the *fude* (brush).

[9] Shambhala Publications, Inc., 3rd Ed., copyright 1995, plate no. 175

Tsuki w/Poetry

#18 – Title:	**Bon Kyo Seiza Shin no Sui**
Translation:	Sitting Quietly – Mind like Water
Specifications:	Ink on rice paper (13.5" x 45") Brushed May 1997

This particular piece was likely Sensei's favorite topic. It illustrates one of the first scrolls he brushed for me. Trying to get the exact translations from Kim Sensei was a tall order most of the time. He used simple expressions to explain the work. It was his way of getting me to form a picture in my mind of what the kanji said rather than simply memorizing the translation in English. It is similar to martial arts training, where the end objective is to react to a given situation rather than memorize "defense A, B, or C."

Kim Sensei used many hand gestures when explaining the meaning behind the various shodo he brushed. His explanation for this piece went something like this:

> Quiet room go, some candles. Light incense. Sit down, seiza[10] go. Next, meditation. Clear mind. No thinking. Mind like water. Flowing. All body relax.

His hands were open and outstretched when making the point of sitting down and quietly clearing the mind to become calm while meditating.

The brushwork itself starts out clear and defined. The last three characters are interesting as they become airy, showing the concept behind meditation. The idea is to erase extraneous thoughts and let negative thoughts slowly dissipate.

[10] Seiza is the formal seated posture used by the Japanese. It requires kneeling on the floor with your legs tucked under you and your feet crossed at the toes, with your back upright, hands resting on your thighs.

Bon Kyo Seiza Shin no Sui

#19 – Title:	**Shi Fu Tai Jin**
Translation:	Time Waits for No Man
Specifications:	Ink on rice paper (13.5" x 44")
	Brushed April 1998

Kim Sensei brushed many Shi Fu Tai Jin for gifts to his students and friends. The meaning of this piece is evident. You cannot get bogged down with everyday issues or time will pass you by. Kim Sensei liked to brush these characters quite large to emphasize the point of the kanji.

Shi Fu Tai Jin

#20 – Title:	**Hon Rai Mu Ichi Butsu w/Enso**
Translation:	Originally, Not One Thing. (with Zen circle)
Specifications:	Ink on rice paper (13.5" x 40")
	Brushed June 2003

An enso is a Zen circle that Zen calligraphers use frequently in their art. It has various meanings: a symbol of simplicity, a circle of infinity, emptiness or fullness, that which is visible, etc. It is quite interesting to view the various examples of enso, as they can all be quite different.

Audrey Yoshiko Seo's book, *Enso: Zen Circles of Enlightenment,* is an excellent text on this subject. She writes, "The enso is perhaps the most common subject of Zen calligraphy. It symbolizes enlightenment, power, and the universe itself. It is a direct expression of thusness or this-moment-as-it-is. Enso is considered to be one of the most profound subjects in zenga (Zen-inspired painting), and it is believed that the character of the artist is fully exposed in how she or he draws the enso. Only a person who is mentally and spiritually complete can draw a true one."

Zen calligraphers generally attach some type of poem or philosophical text to the enso to complete the piece. This example by Kim Sensei reads, "Originally, not one thing." This same sample, or *tehon,* is found in John Stevens' book *Sacred Calligraphy of the East.* This is a major part of the teaching process in shodo, to copy the tehon of past masters until your action becomes instinctive. Only then can you proceed to develop art on your own. Stevens writes, "At first it is essential to copy famous pieces of calligraphy by different masters in order to familiarize yourself with the brush, the flow of ink, and the feeling of the characters. After many years of repeating the basic techniques, experimenting with different materials, and deepening your practice, your calligraphy can take any direction."

The work shown here was brushed when Kim Sensei was 76 years old. The enso appears wobbly at first, but remains strong throughout. Kim Sensei's kendo performance was very similar. Although advanced in age and appearing somewhat feeble upon first glance in the dojo, you soon realized how strong his spirit was when you crossed swords with him. Every action you attempted was easily intercepted, and his counterstrikes were jarring. This piece is an excellent example of the "enlightened" mind.

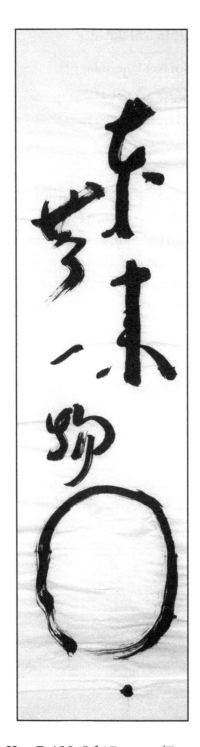

Hon Rai Mu Ichi Butsu w/Enso

#21 – Title:	**Hon Rai Mu Ichi Butsu**
Translation:	Originally, Not One Thing
Specifications:	Ink on rice paper (13.5" x 44")
	Brushed December 2003

This is another example of the kanji presented on plate #21, without the enso. This piece was brushed six months after the first example. Notice the thickness of the line. Kim Sensei actually held two brushes together to produce the desired effect. This is especially revealed in the final character at the bottom, butsu, which has two lines running side by side. Regardless, the effect of his execution is evident, and the artwork is bold and aggressive.

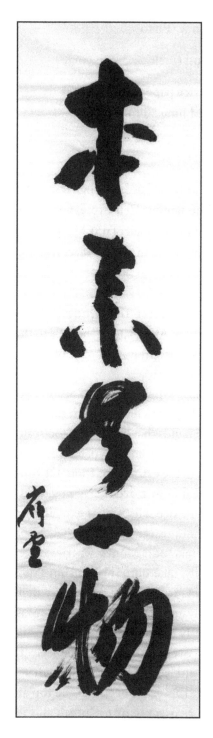

Hon Rai Mu Ichi Butsu

#22 – Title:	**Mushin w/Enso**
Translation:	No Mind (including Zen circle)
Specifications:	Ink on rice paper (13.5" x 32")
	Brushed June 2003

The translation of mu is "nothing" or "nothingness." Shin refers to either the mind or the heart. Together, the famous Zen expression means "no mind." Samurai of ancient Japan strived to attain the state of mushin in their training and especially on the field of battle, which made them able to react instantaneously to an oncoming attack without conscious thought. In other words, they reacted without thinking.

There is a scene in the movie *The Last Samurai* where this concept is highlighted. During a practice session, actor Tom Cruise (Nathan Algren) has a difficult time with his training partner. At one point, he falls to the ground. A young samurai runs up to him and says, "Right now, too many mind." Cruise looks confused and says, "Too many mind?"

The young man explains, "Mind on people around you. Mind on defeat. Mind on sword. Too many mind." After a few seconds, the young man states, "No mind." At this point Algren understands that his mind is too scattered to react according to the situation at hand. He is finally able to match his opponent's speed and timing when he is able to "let go" of the extraneous thoughts running through his mind.

This concept is applicable to martial arts practiced today. Kim Sensei used mushin to help in daily practice. His way of explaining the concept had very little to do with actual technique, but rather in the "preparation" of the mind. He said, "Negative thought, take out. Money worries, take out. Job problems, take out. Argument with family, take out. This mushin Popp-san." He wanted me to eliminate negative thoughts while in the dojo. Only then could I afford the focus necessary to train properly and confront my opponent with effective techniques.

This work is particularly interesting. The kanji for *mu* (no) is highly cursive, yet remains legible in the overall context of the piece. The execution of the enso is reversed. Enso or Zen circles are generally written starting at the bottom and moving from left to right. This circle begins at the top and moves in the opposite direction. Although Kim Sensei seems to "break all the rules" in this piece, the end result remains an attractive piece of artwork due to his many years of practice and control of the *fude*, or brush.

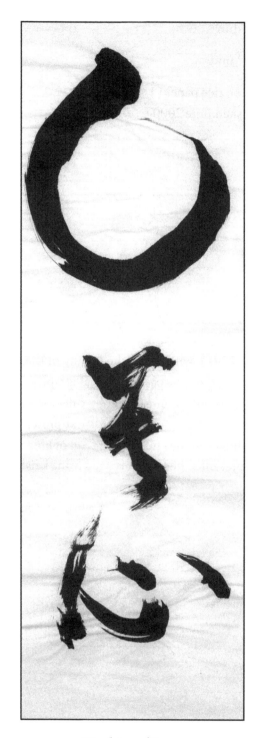

Mushin w/Enso

#23 – Title: **Mushin**

Translation: No Mind

Specifications: Ink on rice paper (13.5" x 43")
Brushed June 2000

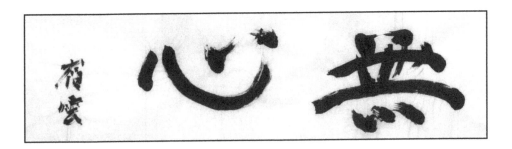

Sen no Rikyu (1522 - 1591), who established many of the basic precepts of the tea ceremony, held that nothing surpassed Zen calligraphy as a subject for display in the alcove of the tea room[11]. Zen calligraphy calls for the exponent to develop *mushin* or a state where conscious thought is not present when executing the brush on paper. Only then can the end result be full of life.

The mushin piece presented here was brushed using kaisho, or standard script.

·

·

[11] *Zen Brushwork* by Tanchu Terayama, Published by Kodansha International Ltd., Copyright 2003 by Tanchu Terayama.

#24 – Title:	**Mushin**
Translation:	No Mind
Specifications:	Ink on rice paper (13.5" x 38") Brushed October 2003

This interesting piece contains all three Japanese calligraphy "scripts" for mushin. The large, central characters are brushed using the semi-cursive, or gyosho script. The bottom right characters are brushed using kaisho script, and the bottom left is an example of the cursive, or sosho script.

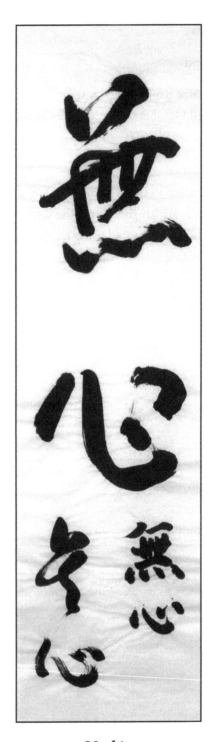

Mushin

#25 – Title:	**Mushin**
Translation:	No Mind
Specifications:	Ink on rice paper (13.5" x 32")
	Brushed November 2003

In this example of mushin, the top character for *mu*, or nothing, is brushed in the highly cursive sosho script of calligraphy. The bottom character for *shin*, or mind, is brushed in the standard kaisho script. It is critical for the artist to "empty the mind" prior to execution of this *tehon* (example). Only then can the characters form in the proper manner. The *mu* character seems to flow naturally, without reservation or hesitation.

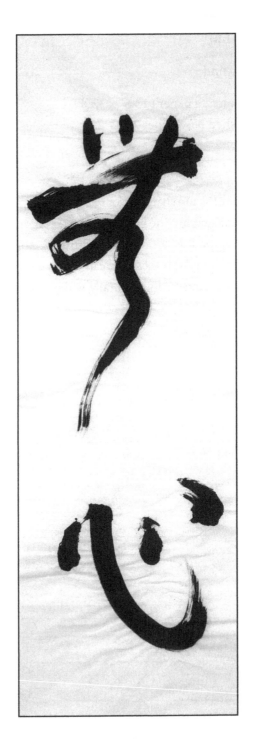

Mushin

#26 – Title: **Mushin**

Translation: No Mind

Specifications: Ink on rice paper (13.5" x 30")
Brushed June 2006

The final example of mushin shown here provides the most insight into Kim Sensei on a variety of levels. This was one of the last pieces he brushed. He was 78 years old, just before he was diagnosed with lung cancer. Kim Sensei was unable to teach me during the last year of his life due to his declining health.

The piece reads from right to left, and both characters are highly cursive (*sosho* script). Shodo is a reflection of the artists' heart and mind. If either is scattered and not focused on the brushstroke, the end result will be lifeless. This piece provides a glimpse of Sensei's "spirit" at this particular time of his life. He was beginning to weather the effects of cancer (this was just before his diagnosis) and this is evidenced by the wobbly appearance of the character on the left (*shin*). Yet the overall context remains well-balanced and reflects a bold result.

The other effect at work here is the simplicity of the piece. It lacks the details expected from a less-seasoned calligrapher who would ensure each and every line

was brushed as perfectly as possible. Kim Sensei is clearly abandoning the standards or "basics" of shodo in this work and is freely expressing the combination of his mind, body, and spirit. However, the end result remains fully legible, which is not an easy task and takes years upon years of practice.

I correlate the "simplicity" aspect of this work to that of other well-known artists using other mediums such as painting and sculpture; specifically, the work of Michelangelo Buonarroti (1475 - 1564). At a certain point in his career, Michelangelo appeared to leave his sculpture in an unfinished state. The detail was not provided. In 1527, the artist, at the age of 52, was commissioned to create a sculpture for the tomb of Pope Julius II. Four separate pieces called *The Captives* were a part of the final product. Each of the four subjects in this work appears to be sticking out of the marble slab, with a focus on the torso of the human form. Due to his eyesight problems later in life, Michelangelo had trouble finishing his sculpture. Although this deficiency has been well-documented by scholars, I feel that he left his work unfinished because he entered a new level in his creative process.

Frederick Hartt writes in his book *History of Italian Renaissance Art*[12] concerning *The Captives*[13],

> For all their mass, not to speak of their superhuman strength, the figures are oddly soft. Whatever might have been Michelangelo's conscious intent – and he must have thought he would finish the statues – their present condition reveals essential aspects of his nature as well as the turmoil of the years during which he worked on them. To watch these giants struggle to free themselves from the surrounding marble has for four centuries been a strongly empathetic experience for viewers. If the great artist could miraculously return and carve away the rough marble, we would probably miss it.

I don't believe his conscious intent was to return and finish the statues. He purposely left them unfinished. For those who understood, he left the viewer with the responsibility of "filling in the pieces," so to speak. This was a bold move at that time.

[12] 4th Edition, Prentice Hall, Inc., Text Copyright 1987 Frederick Hartt, Copyright 1994 Harry N. Abrams, Inc.

[13] Plates 568 – 571.

Rather than try to please the masses, he left his art in this "state" only for those who "got it," for those who understood what he was trying to do.

This approach (the appearance of an unfinished product) can only come after numerous years of study and practice. Kim Sensei had clearly entered that phase of his shodo brushwork. In other words, it is up to the viewer to fill in the blanks. For those of us who understand or "get it," it is a very interesting piece of art.

#27 – Title: **Ichi**

Translation: One

Specifications: Ink on rice paper (5" x 10")
 Brushed August 2000

Ichi is the most fundamental character found in shodo, yet it can be one of the most profound insights into the mind of the calligrapher. John Stevens writes, "The *raku-hitsu*, the instant the brush first comes into contact with the paper, reveals the state of mind of the calligrapher."[14] If his mind is dispersed or agitated,

[14] Sacred Calligraphy of the East, by John Stevens. Copyright 1981, Shambhala Publications, Inc. 3rd Ed.

the character will be weak and "forced." If performed with the correct state of mind, then the kanji will have varying characteristics; it will be full of life.

Kim Sensei always instructed me to end every practice session with the basics, such as this single kanji. He said, "Seizan, life is basic. Shodo practice, same. No rush. No hurry. Basic need. No more." Near the end of practice, it is easy to become preoccupied with the upcoming events of the day. However, you need to maintain the proper focus and energy with the very last action of your practice, just as you did with the very first. This is not always easy to do. Although the brush stroke is simple, it is very difficult to remain fully consumed and remain "in the moment" at the end of practice, and this will be revealed by the result of brushing *ichi*.

This particular piece was brushed with a very large brush. Going from a standard size shodo brush (*fude*) to a larger one is not easy. Kim Sensei could take the same brush used for the example above and then turn around and brush my nickname *Seizan,* as small as he wanted (approximately 3" x 3") using only the tip of the brush. Kim Sensei mastered the brush equally as well as he mastered the sword.

BRUSHING WITHOUT RANK

I n my fifteen years of kendo training under Kim Sensei, I reached the level of 4th degree black belt, or Yon-Dan. Considering Sensei's background in the martial arts and his status in the kendo world community, this was very gratifying. I could measure my accomplishment in concrete terms, which seems to be the American way of thinking. We all want to know "where we stand" at all

times. We need titles and status to measure ourselves against others, to know who is in charge, who we answer to on the job, etc. In the martial arts, this is no different. Rank is central to the various ryu, or styles, of martial arts so the students know who to follow.

For my shodo training, quite interestingly, Kim Sensei never issued any rank to me during that same amount of time. I was the only student who asked him to teach the art of shodo in the first place. Not once did I ever ask Sensei if I would be awarded any rank either. I noticed in various books that I purchased that exponents of shodo were ranked at some level of black belt. I was just so happy to have the opportunity to learn from Kim Sensei, that it never entered my mind to worry about attaining any level of rank or status within the

art. I can arguably assume the rank of Mu-Dan, or no rank, in the art of shodo. Although this may be the case, I am completely happy with the situation. I get total fulfillment just from practicing the art of shodo, and I feel this is the least I can do to honor Kim Sensei.

I do sometimes wonder what the value of rank would be for me anyway. After obtaining a specific level of black belt, people tend to "rest on their laurels" and not feel as though further practice is needed. This is a big mistake, as more rank provides opportunities to improve in other areas of your art. Kim Sensei provided his students in kendo the following words from Mochida Seiji, a high-ranking exponent of the Mugai Ryu style of swordsmanship:

> For me, I finished my basic kendo technique when I was fifty years old. This is contrary to most people. During youth, people master basic technique within one or two years and then consider their study finished. This is a big mistake and is the wrong way of thinking. After fifty years of age, I started the study of real kendo. During my 60's, my body was becoming weak. Therefore, my spirit and mind had to cover for this weakness. I was mentally strong and worked for this. During my 70's, my poor health condition was getting worse and my mind was also growing weak. However, I tried to read my opponent's mind. By eliminating mental weakness, I could read other people's minds. I could read what people's minds were reflecting. In my 80's, there was no mental weakness, but I could get distracted. At this level, I'm studying mind control so I won't become distracted.

In essence, Mochida Seiji expresses the need to improve continuously beyond mere technique. When people receive rank or degrees, they think they are done or have reached the end, which couldn't be farther from the truth. At the time when they receive rank, they need even more practice. The Japanese refer to this as *shoshin*, or beginner mind. So having no rank in the art of shodo is a good thing in my training and practice. I can simply focus on the process of the art itself, rather than worry about ranks or titles. I guess I'm trying to practice the art of shodo in its purest form.

As noted previously, Kim Sensei passed away in May 2007, and I am trying to deal with that "void" in my life. I need to deal with the frustration of not having

him there to guide me and help through all of life's trials and tribulations. How would you deal with this void? You must research as much about your chosen "path" as possible, whether it is martial arts or shodo. In other words, at a certain level you need to develop the mindset that your sensei will not always be there and that you *can* progress without his or her presence.

The research stage of martial arts or shodo training is critical and not an easy one. However, if you can develop this attitude, you will be well on your way to developing the ability to carry on your development with or without assistance. Once developed, this ability never goes away. My kendo sensei researched his arts for nearly seventy years, yet he continued to bring training session handwritten notes with ideas and thoughts on training and teaching to every training session. Without this form of research and introspection, his involvement in kendo or shodo may have ceased a long time ago.

Most martial artists are familiar with *The Book of Five Rings* written by the famous swordsman, Miyamoto Musashi. He breaks learning into five levels or elements such as earth, water, fire, wind, and the void. Why did he address void as the last element? Well, does anyone truly discover or figure out the "way" of the martial arts during a lifetime of research and study? I feel that true teachings of the "way" are handed down after the teacher passes away. If the student paid attention during the instructor's lifetime, he or she will understand the "way" even after the teacher is gone.

You can view this another way. When you are learning directly from your sensei, your sensei is the art. You rely heavily on his or her guidance, and you look forward to training sessions with your sensei because you know you'll get something out of the workout such as good exercise, additional technique explanations, questions answered, etc. However, when the sensei is no longer there, then *you* must become the martial art. You must become the "way."

In shodo, the ultimate gesture that can be bestowed upon a student is when the sensei allows the student to use his or her own brush. The brush is used to transmit the practitioners' mind and spirit onto the paper. Those who study shodo guard their brushes closely and treat them with the respect similar to that of a police officer with his gun. The only time I ever touched Kim Sensei's brush was when he was demonstrating the brushstrokes with his hand over mine. I was never allowed to use his brushes by myself. Now that he has passed, I am to a degree, trying to "hold Sensei's brush" by continually striving to improve myself and ensure that the spirit he conveyed in his shodo will carry on.

The following pages provide samples of my work over the years.

#28 – Title:	**Ryu**
Translation:	Dragon
Specifications:	Red ink on rice paper (16.5" x 29")
	Brushed March 2009

The inspiration for this piece comes from the book *The Sword of No-Sword – Life of the Master Warrior Tesshu*, by John Stevens (Shambhala). This book presents the life of the samurai, Yamaoka Tesshu (1836 – 1888), who founded the Muto Ryu of Japanese swordsmanship. Among being one the finest swordsmen of his day, Tesshu was also a highly accomplished shodo artist, and his pieces are highly sought after by collectors. His effort and training ethic for both his martial arts and calligraphy are legendary.

Tesshu's work is likely my favorite, and I have two of his tehon (examples) brushed as part of my work in this book. For experimental purposes, the piece presented here is brushed using red ink as opposed to black ink, which is traditionally used in shodo art. One often sees fictionalized dragons portrayed in red color. The character was painted quickly, with as much energy and spirit as possible, as if in the middle of a martial arts technique, where the end result is imagined in the mind prior to even making the attempt. In other words, seeing a mental picture of the successful result prior to physical action. Once the picture is set in the mind, the body takes over and completes the motion.

As John Stevens points out in *The Sword of No-Sword,* "when the calligrapher writes no-mindedly in the here and now, the brush strokes are vibrant; if one is distracted or full of delusion, the lines will be dead no matter how well they are constructed." This is the goal of shodo practice and can only be (hopefully) attained after many, many years of dedicated practice.

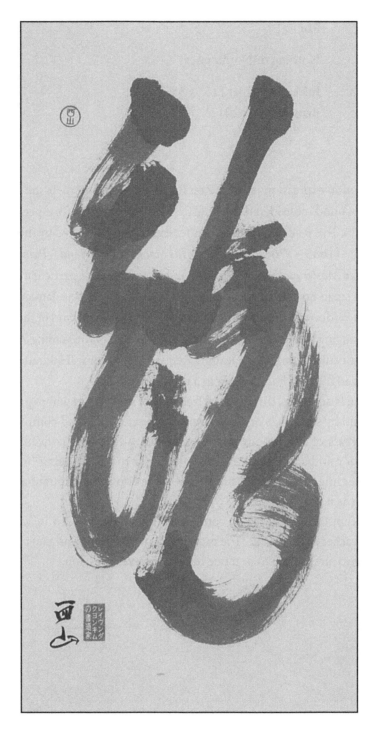

Ryu

#29 – Title:	**Mu**
Translation:	Nothing or Nothingness
Specifications:	Ink on art paper (13" x 38")
	Brushed May 2012

Mu is a common expression used by Zen Buddhist monks in their shodo practice. It is a "state of mind" considered essential for many forms of budo, especially in kenjutsu or kendo. This piece was patterned after the example brushed by the Zen priest Hakuin Ekaku (1685 – 1768) in the book *The Sound of One Hand – Paintings & Calligraphy by Zen Master Hakuin* (Shambhala Publications). This particular exhibit was presented at Japan Society in New York City (October 1, 2010 – January 9, 2011). The exhibit was devoted entirely to Hakuin, was the first of its kind in the West, and offered 78 hanging scrolls. He was widely known as one of the leading Zen masters of the last five centuries and was a leading Zen artist of his time. Hakuin's brushwork is characterized by thick lines, almost in a playful manner.

When mu is achieved, there is total freedom of movement where practitioners are not bound by standards or rules. They can react swiftly and completely. Only after many years of continuous practice can they attain such concentration and unification of mind and body. Athletes often refer to this as being "in the zone." During these times, the athletes simply put aside conscious thought and react to the situation as it is presented.

The concept of mu is a major component of shodo, as seen in Kim Sensei's brushwork earlier in this book. The example provided here was a favorite of Kim Sensei. He encouraged me to practice mu during every session.

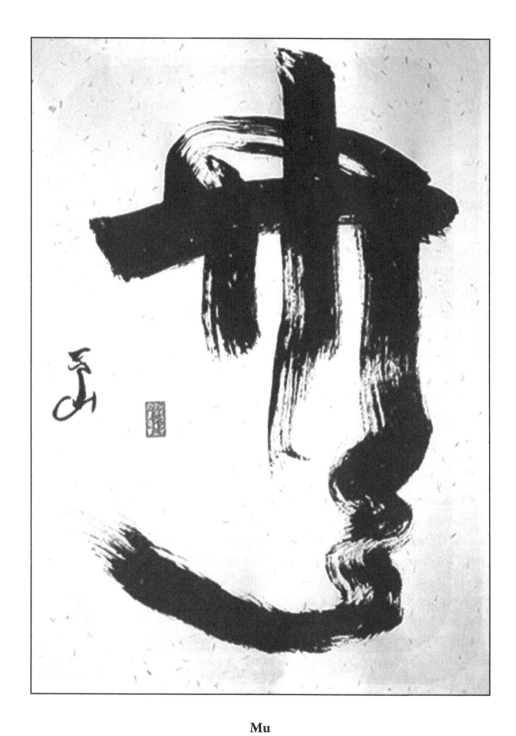

Mu

#30 – Title: **Isshin Ryu**

Translation: One heart method

Specifications: Ink on rice paper (13" x 42")
 Brushed April 2003

Isshin Ryu is a style of karate founded by Tatsuo Shimabuku (1908 – 1975), who was born in Chan, Okinawa. After many years of studying two older Okinawan styles, Shorin Ryu and Goju Ryu, Shimabuku combined what he felt were the best elements of both styles to form his own system of Isshin Ryu on January 15, 1956. Many of the senior instructors of karate on Okinawa at the time did not agree with Shimabuku's decision to formulate a new style. Although he was sometimes shunned, and Isshin Ryu was not formally recognized for many years, he persevered. Today, Isshin Ryu has practitioners around the world and is recognized as a major branch of karate. The "shin" portion of the title (2nd kanji character in the example) can refer to either "heart" or "mind," and the terms are used interchangeably by those who practice the style. However, one heart method or style is considered the literal translation.

The title Shimabuku selected for his new style of karate was not original. Isshin-ryu is also a major branch of a traditional school of *kusarigamajutsu* that was founded in the 17th century by Harayuki Uemon Ujisada[15]. This traditional Japanese martial art is discussed in the book *Old School: Essays on Japanese Martial Traditions*[16] by Ellis Amdur. Kusarigama is a martial art that deploys the use of a scythe or sickle with a long chain attached to it. This Japanese system can be traced back to the 14th century, where the samurai Nen Ami Jion created the weapon of this style after having a vision of a divine being holding a sickle in one hand and a metal weight in the other. The modern-day techniques of Isshin-ryu Kusarigama were compiled and incorporated in the 17th century by the unification (tan'isshin) of Ujisada. Interestingly, Tatsuo Shimabuku had a similar type of vision in the founding of his Isshin-ryu Karate. The "vision" or "dream"

[15] http://en.wikipedia.org/wiki/Isshin-ry%C5%AB_kusarigamajutsu
[16] Copyright 2002 by Ellis Amdur, published by Edgework.

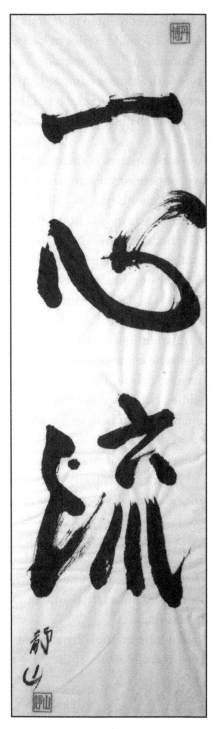

Isshin Ryu

Shimabuku experienced is well-documented in various texts, and we know for a fact that he, in effect, "unified" two older styles of karate to form his Isshin-ryu. Are these two points coincidence, or did Shimabuku call upon the historical facts of this kusarigamajutsu style with a similar name to help him label his new karate system? This is speculation, of course, but masters of the Okinawan martial arts would have had a strong grasp of the historical facts involved in the various martial arts of China and Japan.

Research of many of the early masters of the martial arts seems to indicate an affinity towards peace, love, or harmony. Examples include Jigoro Kano (1860 – 1938, founder of Judo) and Morihei Ueshiba (1883 – 1969, founder of Aikido). When the purpose of the martial arts moved from "battlefield necessity" towards becoming a "way" or "art," it became obvious that the purpose of training was to cultivate the inner spirit of the practitioner. Volumes of books have been written about these two masters and the importance they placed on having students with a "good heart." In 1918, Kano stated, "The worth of all people is dependent on how they spend their life making contributions"[17].

I believe the founding of Isshin Ryu karate was along those lines. Shimabuku was looking to synthesize what he felt were the critical elements of two older Okinawan styles. This fact is beyond debate. The name he chose for his style has nothing to do with physical abilities, but rather an emphasis toward the type of "heart" displayed by the practitioner. Early students of Shimabuku had plenty of "heart" and were considered ferocious fighters.

Having met many of them in my karate travels, I've discovered they all possess "heart" in a much different manner. The "heart" I refer to is a caring and helpful spirit toward all of human kind. Isshin Ryu karate has grown immensely throughout the world due in large part to the quality of those American Marines who exported the style from Okinawa. However, they also possessed a true "heart" that has been described in books of many masters from long ago. Although I never met Tatsuo Shimabuku, I am convinced that he possessed this type of heart, as evidenced not only by the name of his martial art, but also of the quality of students he produced during his lifetime.

With respect to the calligraphy example here, many traditional martial arts dojo will generally display a piece like this of the style they practice. There are

[17] http://en.wikipedia.org/wiki/Kano_Jigoro

numerous pictures of Master Tatsuo Shimabuku standing at the door of his dojo in Okinawa that show the above kanji painted on the entrance.

My karate sensei, Master Toby Cooling, trained with Master Shimabuku on Okinawa in 1969 and 1970. Master Cooling recalls of his time on Okinawa, "When Master Shimabuku entered the dojo; you could just feel his presence. It was like a cold chill at that moment. His spirit and confidence was so strong." This relates to the "heart." Master Shimabuku had trained so hard for so long, his command of martial arts techniques and concepts led to enlightenment of his true nature and purpose. . . to care for and nurture his students to become better, not only with karate, but with life itself. Master Cooling said, "He made you *want* to do well, to impress him."

Master Shimabuku used no formal instruction or curriculum in his dojo. He referred to warm-ups as "steps." Master Cooling notes the other areas covered were fighting techniques, kata (forms), and kumite (sparring). He provided minimal verbal instruction; his preference was to ensure you *felt* the proper application of a particular technique. He left students to their own devices many times to work on the techniques by themselves. After some time elapsed, he returned to check on their progress. If not sufficient, he simply shook his head as a grandfather might do to a young child who was misbehaving.

In today's society, we want to be able to perform the techniques immediately. In Isshin Ryu Karate, we often refer to the three "arrows" of training (physical, mental, and spiritual). Often, the first two arrows are the primary focus, and the spiritual arrow is neglected. A major reason for this is that the spiritual "arrow" takes the longest time to understand and demonstrate. For most of us, learning the techniques properly takes many years of committed study and practice. As Master Cooling notes, you have to *believe* in yourself and the technique will work. This confidence to believe in yourself cannot be developed in "8 easy lessons to martial arts expertise," as is sometimes advertised. It takes a lifetime of commitment. After years of hard work, students begin to understand that the applications of techniques are not limited to physical actions. Those who fully understand the true nature of martial arts are able to defeat an opponent without the use of a punch or a kick. Tatsuo Shimabuku worked hard to transmit this concept to all of his students.

#31 – Title:	**Sui Getsu**
Translation:	Water / Moon
Specifications:	Ink on rice paper (12" x 31")
	Brushed January 2000

Kim Sensei brushed in thick, bold lines often to express a straightforward and powerful intent. This was my intent in this example. Although the result demonstrates power and energy, the underlying concept of "flow" and gracefulness is evident in the top character for water (sui). The martial artist must be strong, energetic, and fully committed to the task at hand. Without proper flow with both body and mind, success can never be achieved.

"Water – Moon" is a major topic of both swordsmanship and Zen. Water receives the moonlight without discrimination; the moon shines brightly without discrimination. There is no thought, no worry, and no concern over any type of action. Everything is as it should be.

I relate this concept when teaching Isshin Ryu karate. I teach each and every student with respect and without discrimination, everyone receives instruction in the same manner. I try not to judge them and teach them at their "level" of receiving the information. If this can be accomplished, then the student will absorb the martial art being studied the way the founder of the system intended, and the teacher will come to know and respect his sensei even more.

Sui Getsu

#32 – Title: **Wa**

Translation: Harmony

Specifications: Ink on rice paper (Kanji - 11" x 11")
 Brushed December 2006

Harmony is considered one of the greatest of virtues. It is something that I strive for in my practice of the martial arts. Not only to have my practice and skills in harmony, but to be in harmony with those around me, to remain humble and encouraging to everyone. Harmony can also refer to being at peace with oneself in order to get along with others.

This is an essential element of martial arts training. If those who are practicing are not in harmony, there will be difficulty in learning the arts properly, as the founder would have intended. Thus, the Japanese martial arts exude a distinct sense of harmony. Although other terms may be used to describe harmony displayed by championship teams in various sports, it is undoubtedly a critical component of those teams.

Shodo is a picture of the mind of the artist. This character has a great degree of dry, airy brush strokes called kasure. The intent is to express to the viewer that *wa* should be a continual state of mind and not a one-time action.

Wa

#33 – Title:	**Ryu Ka**
Translation:	Power of Tradition.
Specifications:	Ink on rice paper (12" x 24")
	Brushed 1999

Ryu is discussed in Dave Lowry's *Sword and Brush*, as "the flow of formal traditions of all the arts of Japan, including the bugei." As such, most systems of the martial arts end with the suffix Ryu such as Isshin ryu, Goju ryu, Shorin ryu, and so forth. The traditions followed inside of the dojo are critical to those highly initiated and serious in their training. They help to form a bond among the practitioners. Senior students (sempai) ensure the younger students or lower ranks (kohai) follow them closely. When students see how much the other students respect the traditions being followed, they begin to appreciate how important they are in the overall context of learning the martial arts. Therefore, following those traditions becomes an empowering part of the learning process. It ensures the spirit of those who have gone before is preserved and not forgotten.

What happens inside the walls of the Karate dojo? Obviously there is teaching and learning involved in the running of a traditional dojo. You practice the fundamental techniques until they become a "part" of you. Action and reaction begin to occur without thought. The other aspect of dojo culture critical to its value is the conduct of the sensei, or instructor. The sensei must set the example, to outline the proper "way" or moral code to be followed. As a sensei, you become obligated to the students to see to their improvement. The head of the dojo must show a level of maturity that is respected by everyone, to show there is something more powerful to learn than simply a punch or a kick or to defeat someone. The proper traditions and ethos, as handed down by those who formulated the martial arts into their current context, are the highest ideals to learn. As such, the power of these "traditions" helps the student to honor those who have gone before and passed the art down in the proper manner.

We can relate various "traditions" to our way of life in this country. Consider the various traditions that you may follow subconsciously. A prime example would be during the Christmas holiday season. Your family may follow various traditions while celebrating the holidays. This brings further meaning to you and your family; it helps to heighten the purpose of what is being celebrated. The "power of tradition" should never be underestimated.

Ryu Ka

#34 – Title:	**Kokoro tadashikereba sunawachi fude tadashi**
Translation:	If your mind is correct, the brush will be correct.
Specifications:	Ink on rice paper (13" x 42")
	Brushed Spring 2000

The *tehon* or sample used for this piece can be found in two books authored by John Stevens, *The Sword of No Sword* and *Sacred Calligraphy of the East*. The original work was brushed by the master swordsman Yamaoka Tesshu (1836 – 1888), founder of the Muto-Ryu (no sword) style of swordsmanship. John Stevens has authored Tesshu's biography[18] where he notes a Chinese emperor asked a renowned calligrapher how to hold the brush. The emperor was told, "If your mind is correct, the brush will be correct." In essence, the calligraphy must be brushed without any extraneous thought. If this can be achieved, the calligrapher's spirit will clearly shine through in the finished product and the brush strokes will look vibrant and timeless. Tesshu's shodo exemplifies this "no mind" concept in his calligraphy very well.

After many years of practice, shodo provides a pure and accurate picture of the calligrapher's mind. H.E. Davey[19] writes, "Brush strokes reveal the state of the body and subconscious mind – including its strengths and weaknesses – at the moment the brush is put to paper." When looking at Tesshu's shodo, it appears as though he had boundless energy and his execution of the brushwork had no reservations. This can only be attempted after years of practice in the basics. This same process applies to any of the budo forms (e.g. karate, judo, kendo, aikido, etc.). Years and years of practice in the basics are mandatory in the martial arts prior to attempting to express your inner spirit freely in your forms or fighting. In this sense, there is a great degree of parallel between martial arts and calligraphy. Little wonder the samurai of ancient Japan took a keen interest in the traditional arts such as shodo.

[18] The Sword of No-Sword: Life of the Master Warrior Tesshu, by John Stevens, Shambhala Publications, Inc.

[19] Brush Meditation: A Japanese Way to Mind & Body Harmony, by H.E. Davey, Stone Bridge Press

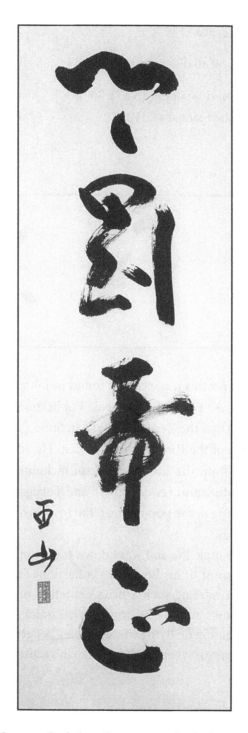

Kokoro tadashikereba sunawachi fude tadashi

#35 – Title: **Hogejaku**

Translation: Cast off all discrimination.

Specifications: Ink on rice paper (13.5" x 36")
Brushed January 2012

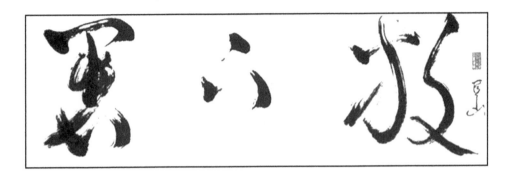

The sample, or tehon, for this piece can be found in John Stevens' book, *Sacred Calligraphy of the East*, 3rd Edition: Shambhala Publications, Inc. The artist who originally brushed this was the Zen monk Takuan Soho (1573 – 1645). Takuan was a major exponent of the Rinzai school of Zen. He advised and befriended many notable figures from the history of Japan including Miyamoto Musashi (swordsman), Yagyu Munenori (swordsman), and Tokugawa Iemitsu (Shogun). His writings, culminating in the popular text *The Unfettered Mind*, are studied by martial artists to this day.

Takuan led a very simple life and was known for his high integrity and character. He traveled for most of his life taking collections for the various temples throughout Japan. Considering such a plain existence, one can see the reason behind the topic as shown above. The brushwork is quick and to the point. This helps to bring out the kasure or 'flying white' (drying) effect of the ink. This is the visual effect I tried to mirror when studying Takuan's actual example provided in Mr. Stevens' book.

#36 – Title:	**Mukan**
Translation:	No barrier.
Specifications:	Ink on rice paper (13" x 17") Brushed June 2012

For this piece, I'm trying to pattern the brushwork of Kim Sensei's examples in #21 and #22, which are both near the end of his life. The concept behind *Mukan* is not to allow anything to deter you from whatever your goal is or from anything you wish to accomplish. I took that philosophy to heart and wanted to attain professional credentials in the field of information technology. I sought to become certified as an auditor of IT to complement my job. Considering my ongoing responsibilities with work and family life, I planned to study for the exam starting 12 months prior to the actual test. I worked hard to find any time I could to study the review course materials – while in travel status for work, during weekends, and late at night after my kids went to sleep. Anywhere I could squeeze in a few minutes to study, I reminded myself that I would not let any barriers stand before me in my goal to pass the exam. My work paid off as I passed the CISA exam in June 2011.

Mukan, no barrier, can be applied anywhere, anytime, for any reason. I've used it many times over the years. During the grueling physical therapy required after ACL reconstruction of my left knee, Mukan became my mantra. I decided during this period of time that I would not only get back to my normal martial arts routine, but I would even go as far as becoming actively involved in distance running. I told myself there are no barriers before me that could prevent this from happening. Using Mukan as my springboard into running, I've worked my way up to a half-marathon in 2012.

Consider *Mukan* whenever you are faced with a tough goal, a daunting task, or you simply wish to switch gears and go into another profession or hobby. You are only limited by the barriers within your mind. Tear down these barriers by telling yourself, there are no barriers.

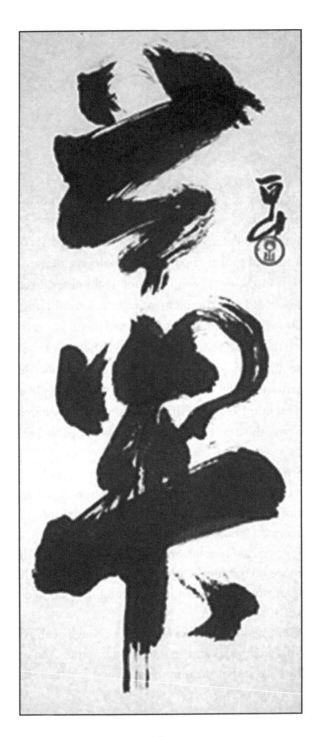

Mukan

#37 – Title:	**Yume**
Translation:	Dream
Specifications:	Ink on rice paper (11" x 14")
	Brushed May 2012

One of my favorite Zen shodo artists is Deiryu Sojun (1895 – 1954). He is featured in The Zen Art Book, by Stephen Addiss and John Daido Loori (Shambhala Publications, Inc.). Deiryu's style seems to be sharp, yet flows extremely well from top to bottom along the paper. Very similar to a martial artist who is able to flow from technique to technique, yet his movement is sharp and effective.

For us, dreams are important. We often seek the meaning of our dreams. They are sometimes good dreams, and they are sometimes bad ones. Dreams are inevitable in our sleep. In our waking hours, dreams are more or less things we hope or wish for….our goals. We sometimes put our dreams to paper so we can use them as a basis for how we plan to achieve them. The dream of owning an art studio, the dream of traveling to a foreign country, the dream of learning your ancestry, and so forth. The Kanji for dream has relevance for just about all of us at some point in our lives.

Dream is a popular topic in Zen as well. The Zen priest Takuan brushed the Kanji for dream as his death poem to his students. Considering he had quite a famous journey in his work as a Zen monk, he perhaps meant his life felt like an honored dream. Zen texts generally indicate life and death, and everything in between, are all a dream and everything is created within the mind.

This art was brushed using four strokes. The standard Kanji for yume, or dream, is performed using 13. In following Deiryu's example in The Zen Art Book, I used a highly cursive style. The cover art is also *yume* in the same cursive script, called *sosho* script.

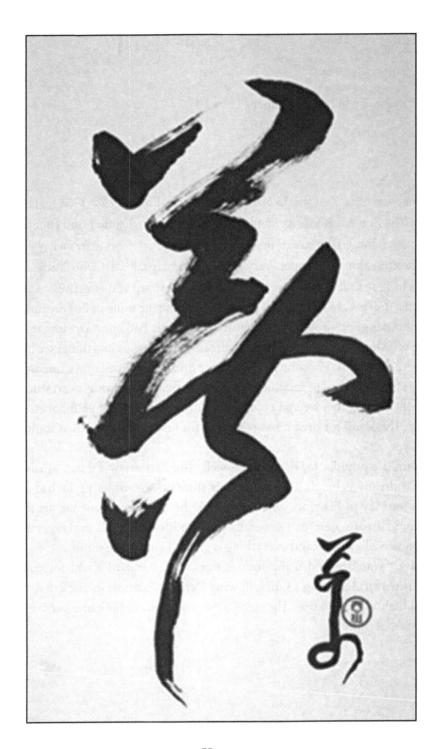

Yume

#38 – Title: **Shin Kan**

Translation: The barrier is the heart.

Specifications: Red and black ink on rice paper (15.5" x 42")
 Brushed February 2010

Shin Kan was brushed with a very large brush. This is a two-tone ink piece with red ink used for the second or lower Kanji for heart, *shin*.

 The heart is often the biggest barrier we face. Sometimes we feel that we are not worthy, that we don't belong, and that we can't reach a specific goal. These thoughts stem from the mind; however, our heart can overcome these negative thoughts and feelings if we allow ourselves not to believe the negative stuff. Many times though, we don't believe in our heart to overcome such barriers. We then may be paralyzed by our inadequacies and are unable to move forward. Again, it is our belief in ourselves that can help us to eliminate doubt and fear. This belief must stem from the heart. When the barrier of the heart is removed, we can accomplish anything.

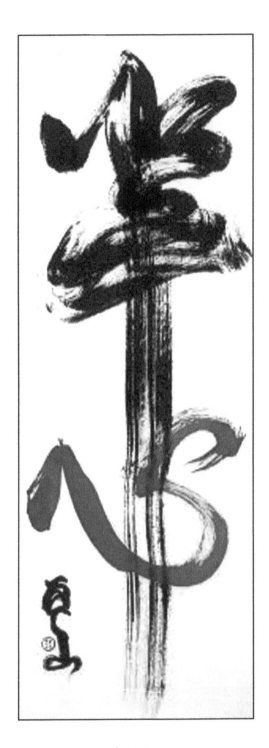

Shin Kan

THE ART

APC: Author's Personal Collection

#	Title	Owner
1	Jiki Shin Kore Dojo	APC
2	Ha Ki	APC
3	Nin	APC
4	Yume	APC
5	Jubei Poetry	APC
6	Ken Ka	APC
7	Mool Tha Hae	APC
8	Shi Sei Itt Kan	APC
9	Nichi Nichi Kore…	APC
10	Kendo Seishin	APC
11	Kendo Seishin	APC
12	Kokoro	APC
13	Butsu Shin	APC
14	Sui Getsu Ken	APC
15	San Satsu	APC
16	Shi Kai	APC
17	Getsu w/poetry	APC
18	Bon Kyo…	APC

#	Title	Owner
19	Shi Fu Tai Jin	APC
20	Hon Rai…	APC
21	Hon Rai…	APC
22	Mushin	APC
23	Mushin	APC
24	Mushin	APC
25	Mushin	APC
26	Mushin	APC
27	Ichi	APC
28	Ryu	Aaron Walker, San Antonio, TX
29	Mu	For sale, Some Saturday Frame Shop, Hummelstown, PA
30	Isshin Ryu	Adam Knox, West Chester, PA
31	Sui Getsu	APC
32	Wa	APC
33	Ryu Ka	APC
34	Kokoro….	APC
35	Hogejaku	Tom Sanson, Beaverton, OR
36	Mukan	Joe Yinger, York, PA
37	Yume	APC
38	Shin Kan	Jeff Wiest, Dauphin, PA

GLOSSARY

bokuju – pre-ground liquid ink

bokuseki – calligraphy produced by Zen monks

bunchin – paperweights used in shodo to hold the paper in place during the execution of the brushwork

enso – circles used in Zen calligraphy

fude – the brush used in shodo

gyosho – semi-cursive script

haiku – a concise style of Japanese poetry, written in syllables of 5-7-5

hakubun – seal or stamp used in shodo where the background is red and the letters are white

hanko – seal used in shodo

hikkan – the handle of the brush or fude

hiragana – the cursive form of the Japanese syllabary

inkan – seal

inochige – the stronger, more resilient bristles found in the center of a brush

jikishin – direct mind

kaisho – standard or block-style script used in shodo

kakejiku – a hanging scroll

kami – paper

kana – Japanese syllabary

kanji – a Japanese written character

kasure – a dry, airy brush stroke used in shodo

katakana – angular Japanese phonetic alphabet used to translate foreign words

kendo – meaning "Way of the Sword."

kukan – the white space between lines and characters

makimono – scroll

nijimi – brush strokes in shodo where the ink "bleeds" or creates a blotting effect

sen – a line

sensei – teacher. Translated as "one who has gone before"

shikishi – thick, pre-mounted paper with gold leaf edging, generally 9.5 inches by 10.5 inches

sho – calligraphy

shodo – the way of calligraphy, or "Way of the Brush"

shojisu – works containing one or two characters

shubun – a seal with white background and red characters

sosho – cursive script

sumi – ink stick

suzuri – ink stone used to grind the Sumi (using water) to create the ink needed for shodo practice

tanzaku – thick, pre-mounted paper with gold leaf edging, generally 2 inches by 14 inches

tehon – a sample that the shodo practitioner uses for practice

waka – a Japanese poem

Lightning Source UK Ltd.
Milton Keynes UK
UKOW06f1815220814

237414UK00008B/229/P